TOWARDS A PROMISED LAND

WENDY EWALD

EDITED BY LOUISE NERI

Steidl
Artangel

Around one in nine people (11 per cent) moved within the UK in the year before the 2001 Census. Most within country moves are over a short distance. Over 40 per cent of migrants had moved no further than 2 km. Another 23 per cent moved 3 to 9 km from their previous address. Fewer than 7 per cent had moved 200 km or more. www.statistics.gov.uk

With around 11 per cent of the population changing address each year, migration within the UK has the potential to cause large shifts in the geographical distribution of the population. A continuing pattern is the movement of people from urban areas to the suburbs and more rural areas.

Traditional resort and retirement areas gained the most as a result of moves out of London and the metropolitan districts. Shire-county districts, smaller towns and more rural areas also gained population from the metropolitan losses in the year leading up to the 2001 Census. This exodus from the cities included members of ethnic minority groups as well as White people. www.statistics.gov.uk

And the Lord said, "I have surely seen the affliction of my people which are in Egypt, and have heard their cry by reason of their task masters, for I know their sorrows, and I am come down to deliver them out of the hand of the Egyptians, and to bring them up out of that land unto a good land and a large land, unto a land flowing with milk and honey." *Exodus, 3.7–8*

25,155 asylum applications, including dependants, were received by the UK government in 2005/6, 21 per cent less than in 2004/5 (32,025). The number of initial decisions made fell by 35 per cent between 2004/5 and 2005/6 from 39,400 to 25,705. Of these, 8 per cent were granted asylum, 11 per cent granted humanitarian protection or discretionary leave and 81 per cent refusals. 14,960 principal applications were removed in 2005/6, 21 per cent more than in 2004/5 (12,290). Including dependants, 17,100 failed asylum seekers were removed, 20 per cent more than in 2004/5 (14,290).

www.statistics.gov.uk

I only knew we were leaving about five hours before we did, I was shocked because I had to pack all my things. We got a suitcase and packed it full of clothes. The only other things I brought up were a photo and a couple of Mr. Bean things. We only had a suitcase of toys between us because my mum wanted to get out of there quickly. Lanny, 11 years old

At first it took ten days from Vietnam, then another week. About twenty days in total. We came by car, then by plane, then by car. I heard them say we might have to cross on a ferry. It was very hard. Long, 13 years old

Asylum seeker: A person who has applied to the government of a country other than their own for protection or refuge ('asylum') because they are unable or unwilling to seek the protection of their own government as defined by the *United Nations Convention Relating to the Status of Refugees 1951* (the 'Refugee Convention'). The Refugee Convention and its 1967 Protocol are the key international instruments in defining who is a refugee, their rights and the legal obligations of states. www.childrenslegalcentre.com

Unaccompanied asylum-seeking child: The definition for immigration purposes is given in the following Home Office information note: "An application is, or (if there is no proof) appears to be, under eighteen, is applying for asylum in their own right and has no adult relative or guardian to turn to in this country." www.childrenslegalcentre.com

Refugee: A former asylum seeker who has been recognized by the government as meeting the definition of a refugee as set out in the *United Nations Convention Relating to the Status of Refugees 1951.* www.childrenslegalcentre.com

Port: A point of entry in the UK (either airport, sea port or train terminal) where an asylum seeker can lodge their claim for asylum. www.childrenslegalcentre.com

Removal centre: Formally called 'detention centres', these are dedicated facilities for detaining asylum seekers and others subject to immigration control. An asylum seeker is liable to detention at any stage of their application. It is government policy not to detain asylum-seeking children except in 'exceptional' circumstances. Despite this, many are detained either as part of a family or because their age is being disputed by the Home Office. www.childrenslegalcentre.com

Moses said, "I have been a stranger in a strange land."
Exodus, 2.22

I just don't really fit in here. I feel at home in Lisburn and Northern Ireland. It's where my family is. The accent's different in both places. Here they just speak normal British English and there they speak Ulster British. In Belfast no one says "What did you just say, Gareth?" Gareth, 12 years old

I feel very happy because there are very good places here. The flowers and sunsets remind me of where I'm from.
Uryi, 11 years old

European Convention for the Protection of Human Rights and Fundamental Freedoms 1950 (ECHR): An instrument of the Council of Europe. Sometimes called 'the European Convention', the *ECHR* was incorporated into UK law by the *Human Rights Act 1998.* Asylum seekers are entitled to protection under Article 3 and cannot be returned to a country where their right to protection under this Article would be breached. www.childrenslegalcentre.com

Barely a year after the enactment of the *Nationality, Immigration and Asylum Act 2002* the Government announced new legislative proposals to reform the UK asylum system. Despite this it does not address the basic problem of the quality of decision-making and serious concerns remain about the way people are treated during the asylum process.
www.refugeecouncil.org.uk

Thou shalt not oppress a stranger, for ye know the heart of a stranger, seeing ye were strangers in the land of Egypt.
Exodus, 23.9

We haven't done anything we like here. We're too trapped where we're staying. We eat things we don't like, that we aren't used to eating. You can't shout and play because there are neighbours. And then, the space is too small.
Rabbie, 13 years old

The best thing about this country is freedom. Another thing I like about the UK is that they respect me as an Afghan and that the rights of the underaged are recognized. I wish for the rights of all children to be respected.
Reza, 15 years old

Four years after the fall of the Taliban, violence continues to plague <u>Afghanistan</u> with attacks on civilians by anti-government forces.

In <u>Angola</u>, people in more than 5,000 households were evicted and their homes demolished in three mass evictions between 2001 and 2003.

In 1994, in the newly independent post-Soviet state of <u>Belarus</u>, the elected President Alyaksandr Lukashenka promised to end corruption. However by 1996 it became apparent that Soviet style authoritarianism was being reimposed with crackdowns on opposition leaders and movements, trade unions, non-Orthodox Christian churches, civil society organisations and organisations representing minority rights.

Warfare in the <u>Democratic Republic of Congo</u> has caused nearly 3.9 million civilian deaths since 1998. Fuelled by pervasive arms trafficking, anti-government militias continue to fight over territory and natural resources.

<u>Egypt</u> continues to experience human rights abuses, including systematic torture, deaths of prisoners in custody, unfair trials, administrative detention, arrest of prisoners of conscience for their political and religious beliefs or for their sexual orientation, wide use of administrative detention and long-term detention without trial and use of the death penalty.

Nearly three years after the US and Allied Forces invaded <u>Iraq</u> and toppled Saddam Hussein's government, the situation in the country remains dire. Thousands of civilians have been killed and maimed and abuses amid the ongoing conflict are widespread.

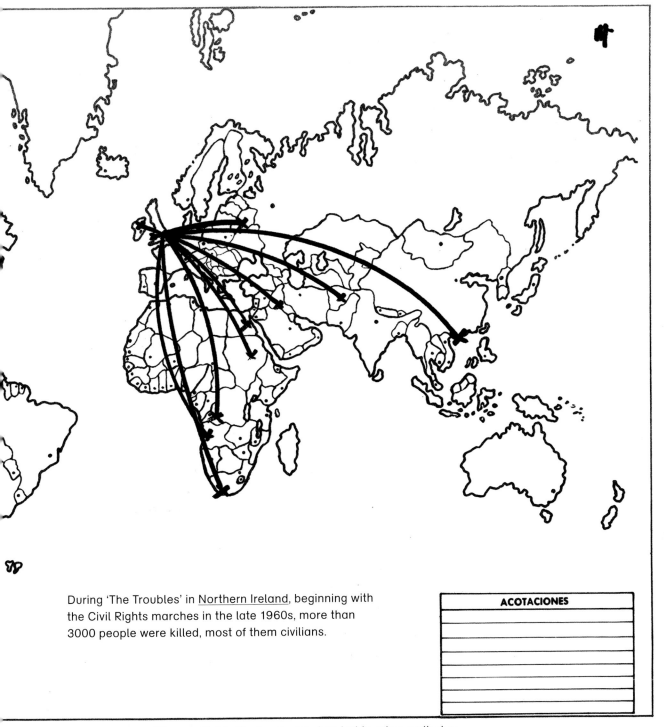

During 'The Troubles' in <u>Northern Ireland</u>, beginning with the Civil Rights marches in the late 1960s, more than 3000 people were killed, most of them civilians.

The conflict in Darfur, <u>Sudan</u>, has led to a humanitarian crisis of epic proportion. Hundreds of thousands of civilians have been killed by both deliberate and indiscriminate attacks and over 2.5 million civilians have been displaced and face starvation.

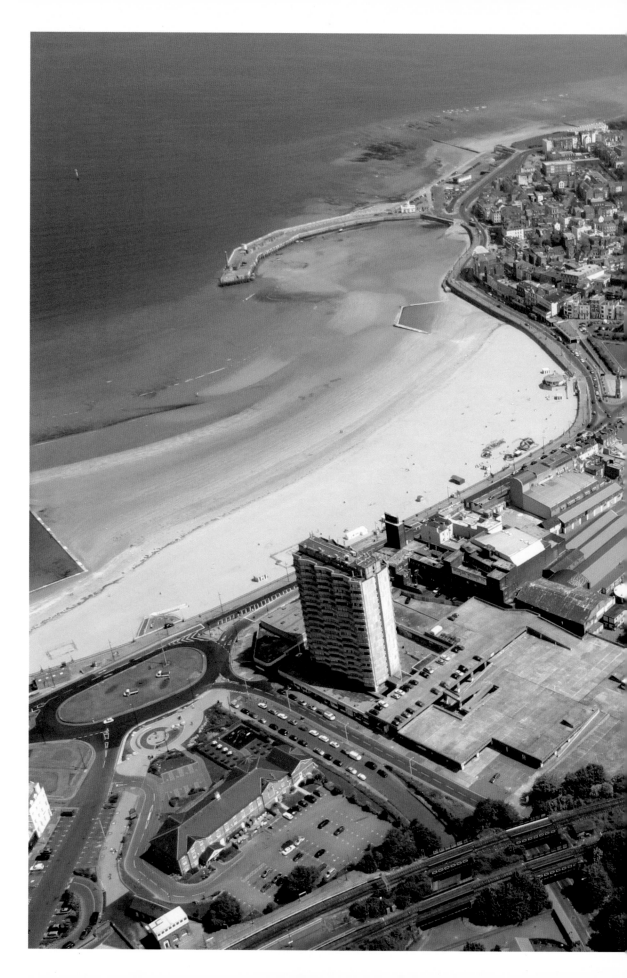

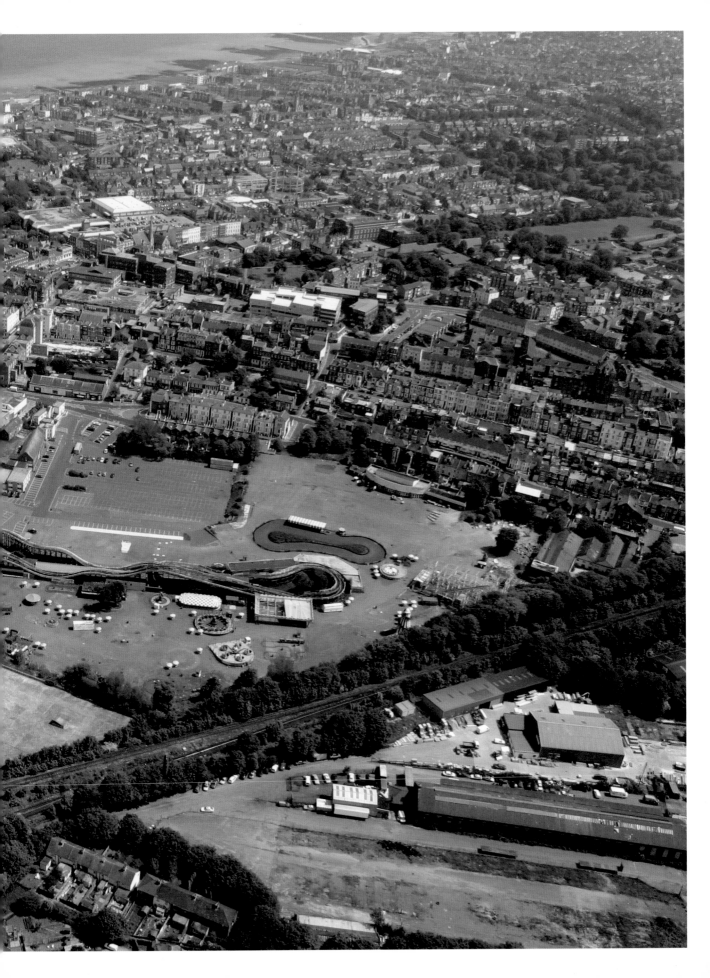

Ashlea *1994, Longfield

Celeste *1997, Democratic Republic of Congo

Christian *1995, Democratic Republic of Congo

Elisio *1993, Angola

Gareth *1994, Belfast

Gemma *1991, London

Glenn *1994, Derby

Lanny *1995, Wales

Long *1993, Hong Kong

Mariam *1995, Egypt

Max *1990, Margate

Omar *1989, Iraq

Rabbie *1993, Democratic Republic of Congo

Reece *1991, London

Reza *1991, Afghanistan

Shakeeb *1989, Sudan

Tarnya *1990, London

Uryi *1995, Belarus

Zaakiyah *1996, South Africa

Zughdie *1993, South Africa

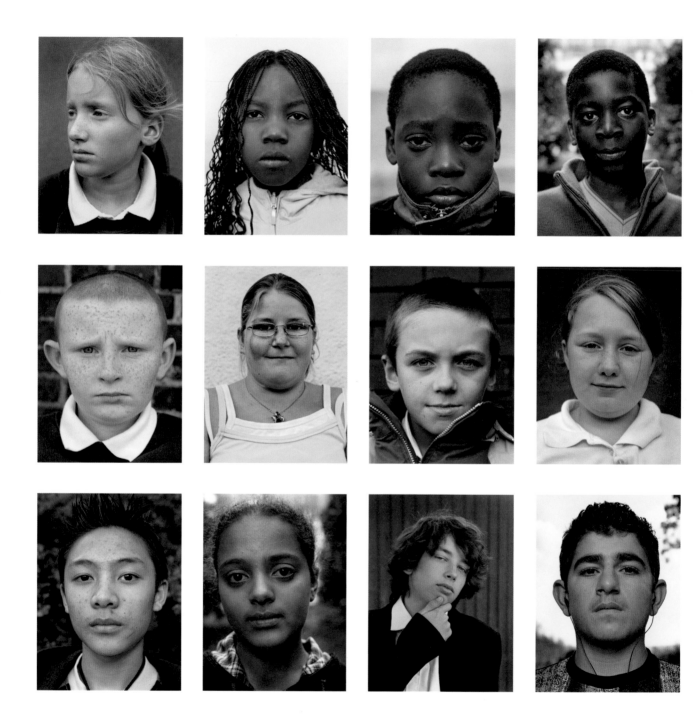

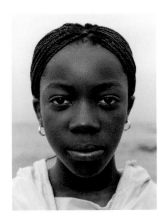 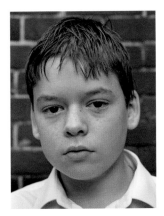 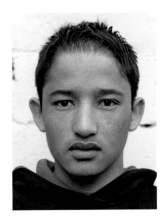 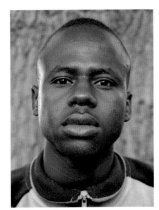

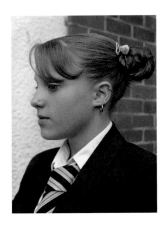 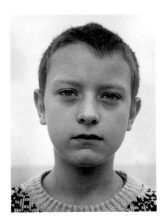 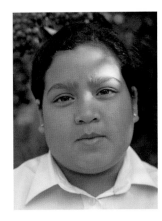 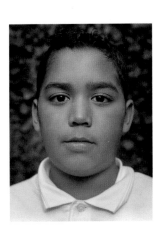

PROLOGUE
BY MICHAEL MORRIS

In 2002, the filmmaker Penny Woolcock and I began to talk about *The Margate Exodus* project in earnest. We'd visited Margate together and both of us felt a keen sense of its faded past as a 'promised land'. We discovered that, for decades, Margate had been a magnet for different kinds of migration by peoples from a bewildering range of places both near and far, drawn by its horizon of possibilities in the hope of a new and better life by the ocean. It was an ideal context, then, geographically, historically and emotionally, in which to revisit the greatest migration story ever told as an artistic collaboration with the residents of Margate.

Penny had met and worked with the American photographer Wendy Ewald some years before. She felt that Wendy could bring a dimension of her own to our fledgling idea. I was aware of the work Wendy had made with different groups of children and went over to meet her at the Queens Museum, New York in 2003, where the silk ban-

ners of her *Arabic Alphabet* project were hanging. We ate
Colombian food and talked about Margate. I described it
as a place of 'refugees', British migrants from within the
UK and others seeking political asylum from desperate
situations much further afield. Wendy imagined collabo-
rating with a group of children in Margate uprooted from
wherever they called home, a group whose common
emotional experiences might cut across the divisions of
race, faith, politics and circumstance.

Shortly afterwards, the teams at Artangel and Creative
Partnerships Kent began the search for this mixed group
of children and Wendy came to Margate to meet them.
And thus *Towards a Promised Land* was born as a
prologue to *The Margate Exodus*, its themes of struggle,
expectation, disappointment and fulfillment given shape
by the imagination of children with cameras. Wendy's
own portraits of the children and the objects they took
with them on their journeys to Margate found their place
as huge images in different public sites throughout the
town, along the sea wall from Palm Bay to the Lido and
in central Margate, around the old Dreamland funfair to
the seat of local government in Cecil Square. The first set
of banners were hung along the sea wall in July 2005,
launched with a picnic on the beach and an exhibition of
the children's interviews and pictures at the Outfitters

Gallery in Margate. Many of the children who had been dispersed by then returned to join us. The rest of the banners were hung ten months later with a celebration at the public library of all the work that Wendy and the children had done.

The migration experience of Wendy's young collaborators is at once the heart and the conscience of our Margate project. It is their stories that we listen to…

A FRIEND TO ALL NATIONS
BY JEREMY MILLAR

Most people know Margate already, or know of it, or at least think that they do; for some, that is sufficient reason for its avoidance. Although Paul Theroux decided to start the coastal tour that was to become *The Kingdom by the Sea* (1983) in Margate, a few short hours spent in the town was enough to persuade him to move on: "I had no stomach for this. And did I have to spend the night here to confirm what I could easily predict? I was repelled by the tough ugly youths, the aimless people, the nasty music, the stink of frying, the gusts of violence. I decided not to stay. Why should I suffer a bad night in a dreary place just to report my suffering?" And so, Theroux "climbed out of Margate in the rain that cold May afternoon, and started my tour around the kingdom's coast". The town has no place in his vision of Britain — his tour only begins upon "climb[ing] out of Margate" — and is left behind.

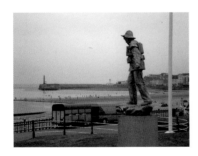

Left behind. Much of Margate, like many of the surrounding coastal towns, appears left behind in one way or another, and usually in many more. This is not simply datedness, a quality that can be reconstituted as a certain charm, but rather something both deliberate and unconsidered: a place forgotten, and deliberately so.

In situations such as this, it is often the ploy of the correspondent to quote from the guidebooks of yesteryear, with a scrap of novel as a natural starting point; from there it is a simple

matter to describe its present-day state, in suitably artificial colours, as symptomatic of the degeneration of contemporary culture, and the poverty — financial, moral, and imaginative — of the masses that consume it. This is not so simple a task with regards to Margate, as it appears never to have existed in a prelapsarian state. In August 1763, the poet William Cowper came to Margate suffering from depression, although the excursion seemed not to prove particularly beneficial to his spirits, as he recalled in a letter some time afterwards:

> But you think Margate more lively — So is a Cheshire Cheese full of Mites more Lively than a Sound one, but that very Liveliness only proves its Rottenness. I remember too that Margate, tho' full of company, was generally filled with such Company, as People who were Nice in the choice of their Company, were rather fearfull of keeping Company with. The Hoy [boat] went to London every Week Loaded with Mackarel & Herrings, and return'd Loaded with Company. The Cheapness of the Conveyance made it equally commodious for Dead Fish and Lively Company...

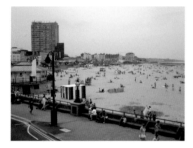 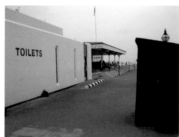

Of course, the correspondent is then at liberty to take the opinion of (usually) his elders, perhaps betters, as confirmation of his own prejudices, and so, when Theroux quotes from an early twentieth-century *Baedeker* describing Margate as "one of the most popular, though not one of the most fashionable watering places in England," he is able to concur: "So it had always been crummy and cockneyfied, just like,this, people down from London for the day shunting back and forth on the front in the cold rain, and walking their dogs and gloomily fishing and looking at each other."

For the urbane New Englander who summers in Cape Cod, Margate no doubt lacks a certain 'class', although class as a social descriptive, even determinant, is never far from any

consideration of the town. Indeed, Margate has been synonymous with 'simple working-class pleasures' for centuries now. When Somerset Maugham (who was raised from the age of ten in the relatively nearby, and more sedate, town of Whitstable) was to describe a working-class interior in his 'slum novel' *Liza of Lambeth* (1897), he notes the mantelpiece, "taken up with little jars and cups and saucers — gold inside, with a view of a town outside, and surrounding them, 'A Present from Clacton-on-Sea', or, alliteratively, 'A Momento of Margate'. Of those many were broken but were they had been mended with glue…"
Of course, the fact that something might seem ruined to an outsider does not mean that it cannot be cherished by others.

For many years, Margate had the reputation as a restorative; one old woman would maintain against all comers that "Margate air would bring a dead horse to life." A guidebook from the 1930s, which describes the climate as "Very bracing. Enjoys a world-wide renown," quotes one possible reason for this as the iodine plant which, growing in profusion, "continually breaking up and impregnating the sea, and passing into the atmosphere destroys all noxious vapours and produces ozone, the life-giving principle of the atmosphere." A belief in the recuperative effects of the seaside and, in particular, sea water itself, had increased markedly throughout the eighteenth century, and had an extraordinary effect upon the development of Margate. This culminated in 1753 with the introduction of the world's first bathing machine by the Quaker Benjamin Beale, an often horse-drawn carriage that would take the sick, lame, or merely inhibited into the waters. As Ingoldsby was to suggest:

> You should go down to Margate to look at the ships,
> Or to take what the bathing-room people call 'dips'.

The Royal Sea-Bathing Hospital opened in 1791 for the "Relief of the Poor whose Diseases require Sea-Bathing", drawing even greater numbers into the town to "take the waters" and thereby providing the financial wherewithal to construct further civic amenities, such as sea walls and the stone pier. Indeed, the curative properties of sea water can be said to have been crucial to the development of the British seaside, whether they were bathed in or drunk in the morning. Such a tonic was said to be good for the bowels: "A pint is commonly sufficient in grown persons to give them three or four sharp stools."

The growing number of visitors, of various social classes, who sought healing in one form or another, desired something quite different from those who came to enjoy the base pleasures of 'Merry Margate', a term which has been used by detractors and admirers alike. At times the discrepancy was as amusing and illuminating as it was unexpected. At the beginning of 1866, as he began making a fair copy of his manuscript of *Das Kapital,* the German philosopher Karl Marx suffered a recurrence of the carbuncles that had long plagued him. On the orders of his doctor, and the advice of his friend and collaborator Friedrich Engels, he removed himself to Margate for a month in early spring where he did little but bathe (and swallow arsenic three times daily). Although the regime proved somewhat beneficial — he began to undertake vigorous walks, even as far as Canterbury, some sixteen miles or so on one occasion — the start of his sojourn was somewhat inauspicious. Arriving at the King's Arms, a pub in Shady Grove, Marx ordered a rump steak and was shown to the coffee room where he took fright at a man, seemingly blind, seated before the fire: "When my supper arrived the man began warming his elephantine feet at the fire. What with this agreeable spectacle, and his supposed blindness, and what with a rump steak, which seemed, in its natural state, to have belonged to a deceased cow, I passed the first Margate evening anything but comfortably." Nonetheless, his mood was brighter than that during a previous stay in East Kent, while holidaying with his family in Ramsgate in July 1864: "Your philistine on the spree lords it here as do, to an even greater extent, his better half and his female OFFSPRING. It is almost sad to see venerable Oceanus, that age-old Titan, having to suffer these pygmies to disport themselves on his phiz, [face] and serve them for entertainment." One suspects that his being confined to his bed with a malignant carbuncle just above his penis might have soured his disposition somewhat.

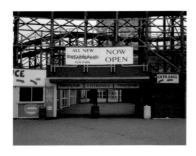

If the disdain shown by Marx towards the working class seems rather surprising, it is perhaps less so when considering the views of T.S. Eliot (in a piece for his *Criterion* periodical that is startlingly reminiscent of Cowper's criticism quoted earlier, Eliot railed against the spread of community singing, fearing it would transform the English individualist into "the microscopic cheese-mite of the great cheese of the future"). In the autumn of 1921, Eliot suffered a mental breakdown, and was advised to leave London for three months; having obtained leave of absence from Lloyd's Bank, where he was working at the time, the Eliots checked into the Albemarle Hotel at 47 Eastern Esplanade, Cliftonville, the rather more exclusive eastern district of Margate. His wife Vivien saw the benefits of their stay almost

immediately, remarking in a letter to a friend that Eliot "looks already younger, and fatter and nicer... being out in this wonderful air all day!" During the day Eliot rested for a couple of hours in his room, or practised scales on the mandolin that Vivien had bought him, although most of his time was spent outdoors, sketching the people of Margate "after a fashion" — one wonders how he must have represented them — and writing in a shelter a tram-ride away from the hotel, overlooking the beach in the centre of the town. The writing was the end section of Part III of a projected long poem that had concerned him all year and that would be published, a year later, as 'The Waste Land'. Towards the end of the fifty or so lines Eliot completed during his three weeks in Margate, the town itself appears:

> On Margate Sands.
> I can connect
> Nothing with nothing.
> The broken fingernails of dirty hands.
> My people humble people who expect
> Nothing.

If the first line is a legend to be found upon the face of a topographic postcard, then perhaps what follows is equally descriptive, even, to use a word no doubt abhorrent to Eliot, 'photographic', a sketch of the people before him and his own dislocated response to them.

The Albemarle Hotel is no more, swallowed within a larger Butlin's complex some decades ago before being demolished to make way for a new development of retirement apartments called, rather inappropriately, Dickens Court. The two women within the just-opened 'show complex' have not heard of the Albemarle and, as they impatiently collate information folders for their prospective buyers — "You'll find our resident's lounges make the ideal place to make friends and catch up on all the gossip" — I decide not to press them further about their famous literary guest. Back in town, there is no plaque upon the shelter where the poet wrote; could Margate have forgotten him? A modern breezeblock building sits next to the shelter, lightly painted, like a slab of ice cream. Along walls on both sides it reads, in bold green capitals TOILETS; perhaps, in this anagrammatic tribute, is Margate's remembrance after all.

In his celebrated and influential essay on Baudelaire, Eliot remarks that although the French poet might have been evil, even damnation redeems one from "the ennui of modern life." Though a rampant misogynist who believed that romantic love was evil, "he was at least able to understand that the sexual act as evil is more dignified, less boring, than as the natural, 'life-giving', cheery automatism of the modern world." Such phrases bring to mind Lindsay Anderson's 1953 film, *O Dreamland,* a twelve minute short about Margate's funfair. Dreamland opened to the public in 1920 (although one would hesitate to imagine Eliot amongst the almost one million people who rode the fair's scenic railway in its first year) and, by the time of Anderson's visit it contained an Art Deco-inspired complex with cinema, penny amusements

and fairground rounds, as well as a modest zoo. Anderson was in Margate to direct (with Guy Brenton) a documentary on The Royal School for the Deaf and had the idea to use some spare film stock, a 16mm camera, and a tape recorder to shoot a film about the funfair with his friend and long-term collaborator John Fletcher as cameraman and assistant. The film opens with a peak-capped chauffeur rubbing down a gleaming black Bentley (perhaps Billy Butlin's, who was chairman at the time) at the side of park, while behind this lone figure of duty, a growing crowd descends down the slope from Marine Terrace towards Dreamland's main entrance. Even more disconcerting than this stark reminder of class distinctions is the sinister, mocking laughter that begins to signal the visitors' arrival, soon revealed to be that of an automaton policeman as he casts a watering custodial eye over the 'Torture Through the Ages' attraction: "This is history portrayed by life-size working models; your children will love it." Except those actually watching it don't appear to love it at all, instead standing dead-eyed at the electrocution of 'atom spy Rosenberg', and the burning of Joan of Arc at the stake. They appear as entrapped as the animals in the barren zoo, staring, walking aimlessly. The sense of the film is ambiguous: are these people blameless prey, like the captured animals (but still animals), or rather somehow complicit in their subjugation ("Drunk Again", "My Resistance is Low" read the sculpted-balloon hats). As embodied by the family restaurant, where vats of bean, peas, chips and sausages are dished up as on an assembly line, to be presented with a surfeit does not necessarily mean either nourishment or satisfaction. As the critic Gavin Lambert remarked in his article 1956 *Sight and Sound* article on 'Free Cinema', the movement of which this film became a key work: "Everything is ugly... It is almost too much. The nightmare is redeemed by the point of view, which, for all the unsparing candid camerawork and the harsh, inelegant photography, is emphatically humane. Pity, sadness, even poetry is in-fused into this drearily tawdry, aimlessly hungry world."

Might the poetry of which Lambert speaks also be that of John Betjeman, most particularly his 'Margate 1940' written thirteen years before Anderson and Fletcher shot their film?

Oh! Then what a pleasure to see the ground floor
With tables for two laid as tables for four
And bottles of sauce and Kia-Ora and squash
Awaiting their owners who'd gone up to wash.

The scene described was from the Queen's Highcliffe Hotel, almost facing the Albemarle where Eliot had stayed some nineteen years earlier. It is a memory of an earlier time, untouched, as yet, by the Second World War, recalled from a position that is far more threatened:

> Beside the Queen's Highcliffe now rank grows the vetch,
> Now dark is the terrace, a storm-battered stretch;
> And I think, as the fairy-lit sights I recall,
> It is those we are fighting for, foremost of all.

Rather than the South Downs, or Salisbury Cathedral, both of which were represented upon government propaganda posters at the time, Betjeman instead proposes the Margate illuminations as that which stands for England, as we are invited to take a stand for them also.

Betjeman hints at something profound, I think, and that is for all its modesty and artificiality — "With tables for two laid as tables for four, / And bottles of sauce and Kia-Ora and squash", its "fairy-lit sights" — there is something absolutely genuine about Margate, which makes it a place to cherish, even, yes, love. This is not to ignore the very real problems that the town now faces — mortality rates for various diseases the highest in the region whereas once they were amongst the lowest in the country; social services stretched by a disastrous decades-old policy of London boroughs packing off families for a new life by the sea — but rather to acknowledge that these are issues that have indeed shaped the town, and the resilience of the people within it. Although many have arrived here in recent years, it is often not by choice, and Margate seems largely to have been overlooked by those fleeing London for a better quality of life, and who have settled further west, or gone on even further, to Broadstairs and Ramsgate. This is not to deny that there have been attempts at regeneration, such as the ongoing development of a major centre for contemporary art, Turner Contemporary, on the site where the great painter used to stay, and would paint for extended periods (once declaring to John Ruskin that Thanet's skies were the loveliest in Europe). But even here ambition is tempered by humility: upon being shown an initial architectural design for the building, a dazzling sail set in the sea, some young residents were dismissive, not because they didn't think it worthwhile, or impressive, but rather because it was 'too good for us'. (So, here seem to speak Eliot's 'humble people'.) However since then, a great deal of work

has been done, and the plans have attained a great deal of public support, and could well go some way in extending how the town is perceived. With its amusements, its distractions, Margate has come to stand, perversely, for something authentic, an authentic working-class experience, and it has changed as those experiences have changed, adapting not only through an economic imperative but also, one feels, because it can do nothing else. At one time the Margate lifeboat held the world record for the greatest number of lives saved; today, those seeking the refuge of political asylum are placed within the town's many empty hotel and B&B rooms. (The hotel in which Mick Jagger and Jerry Hall held their wedding reception now houses refugees). And next to this hotel, overlooking the sea, the figure of a lone lifeboatman peers out towards Nayland Rock and the broken wreck of that record-breaking boat Friend to all Nations, which was lost, with nine crew, on 2 December 1897. Sacrifices will be made, as they always have been, and will continue to be made. Lives saved, lives endangered, and Margate, too, shall act and be treated accordingly. Some may think only of its descent, but like one of Dreamland's rides, it has always seemed to fall. As such, we might do well to remind ourselves of the acid observation, "It's not the fall that kills you, it's the sudden stop". And then let us wish that Margate never stops.

WENDY EWALD: PORTRAIT OF A PRAXIS

BY LOUISE NERI

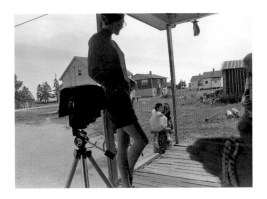

Children have taught me that art is not a realm where only the trained and the accredited may dwell. The truly unsettling thing about children's imagery is that, despite their inexperience with what adults might call rational thinking, their images tap into certain universal feelings with undeniable force and subtlety.

Wendy Ewald

The mysterious image of a divided sea on the cover of this book was taken by an eleven year-old Egyptian girl. On the back cover, a woman crouches on the ground, arranging a pair of small shoes; in front of her, the legs of a child protrude from beneath a photographer's shroud. These paired images speak volumes about the shared domain that is the art of Wendy Ewald.

Wendy remembers being given her first camera, a Box Brownie, when she was eleven years old, and striving to capture the likeness of a small porcelain head that belonged to her grandmother. That same year, her younger brother was hit by a car and sustained neurological damage. She created games with him to help restore his speech and movement. At seventeen, Wendy started art school and began making photographs seriously with a 4×5 tripod camera. Naturally enough, her first subject was her large family of younger brothers and sisters, who acted out imaginative sce-

narios under their big sister's direction. After a year or so, she enrolled in an education class parallel to her art studies so that she might unite her two passions — children and photography. These powerful formative experiences marked the beginning of her lifelong interest in constructing situations for children that "had some kind of result."

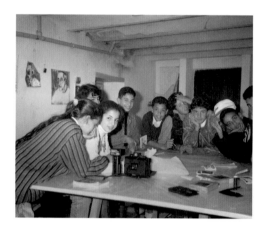

In 1969, Wendy was offered a job working with Naskapi children on an Indian reservation in Canada. She sent them out to record scenes from the reservation where they lived. The uninhibited pictures that the children made were revelatory: "They had a raw power that I had yet to see in photographs. Their work led me to wonder if I could consciously merge the subject of a picture and the photographer and create a new picture-making process." Upon graduating, Wendy moved to Kentucky, one of the poverty-stricken regions of the United States that had been immortalised by Walker Evans in his controversial work for the Farm Security Administration during the 1930s. But, rather than taking photographs, she began to teach at three elementary schools. The size of the schools meant that she could work with every child in the school on a continual basis. It was a readymade "case study" situation. In the absence of any form of art or music, it was a perfect place for her to invent an alternative education, using pictures to teach children

and teaching children to take pictures. Her own childhood barely behind her, Wendy was "conscious of everything they were doing and remembering things I had done myself as a child, and how to engineer a way for those things to come out. So I asked them to photograph both reality and fantasy." With Instamatic cameras bought on welfare or from the proceeds of bake sales, the children set about their work and, over time, produced astonishing results. After a year or so, Wendy began taking her own photographs again and introduced a third activity: to record and edit the children's rich and colourful stories. "The relation between images and texts began to fascinate me. I felt that the images weren't enough. And, after a while I couldn't get away from the combination." The first of these text-image works, *Johnny's Story*, a striking portrait of a rural teenager in the 1970s reveals its young subject as a gifted storyteller.

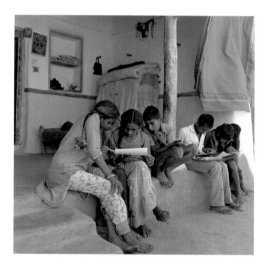

By the late seventies Wendy had invented a form of conceptual art that was not consistent with anything else that was happening at the time although consistent with the aspirations of much conceptual art of the time, it connected with lived reality. She called it "collaborative art." In retrospect, the methods by which she participated in and reflect-

ed upon the events of life echoed the work of educators such as David Kolb who, in 1975, had drawn a diagram of experiential learning as the fluid interaction of four points on a circle — concrete experience, observation and reflection, forming abstract concepts, and testing in new situations.

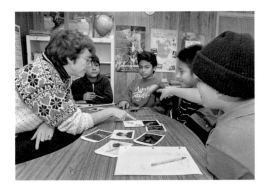

Inspired by the Kentucky project, Wendy sought to continue her explorations further afield and secured a Fulbright Fellowship to work with children in an Andean mountain village. The result was *Magic Eyes*, in which the life story of Alicia, a woman from Bogotá, formed the framework for Wendy's photographs combined with those of the fifth grade Colombian children she had taught there. Travels to India followed where, in rural Gujarat, she worked with a broad spectrum of village children, from farmers to untouchables. In 1991 she went to Mexico, commissioned by Polaroid to make an exhibition. She identified several groups of children in Chiapas and in just two months, they produced "amazing" photographs, full of elaborate and provocative fantasy. Like the Kentucky children, these Mexican children were the first generation who were not labourers. Unlike the Indian children, for whom rural culture was for the most part an oppressive force, they found theirs to be a rich repository of stories, a 'set' in which they could give full expression to their play. As her knowledge of the world developed and with it her work, Wendy became increasingly interested in identifying and dealing with cultural issues of representation. In order to explore them more effectively, she adopted a "binary mode" akin to methods employed in the field of comparative studies. In 1992 in South Africa, she examined the effects of apartheid on Afrikaner children in Johannesburg and African children in Soweto. Although she was concerned that the roles would be too proscribed, the project broke ground in very unexpected ways, revealing the visual dichotomies at play in segregated society. She took up these concerns again later in the 'Literacy through Photography' programme that she initiated in North Carolina in projects such as *Black Self/White Self* where children switched racial identities and roles.

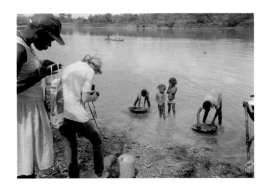

Having broached the issue of colour, Wendy pursued representation to its literal vanishing point by working in Islamic cultures (Morocco, Saudi Arabia) where images were largely forbidden. In these situations, taking pictures became a negotiation between what could and could not be shown; modern life was shown straining against the boundaries of tradition. Through these unfamiliar and challenging experiences, Wendy underwent an intensive programme of 'situated learning,' taking into account through intensive dialogue with her subjects the differences in cognitive and communication styles that are culturally based, as well as attending to different cultural models of selfhood.

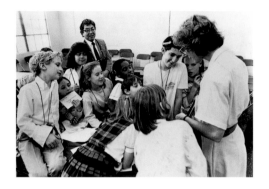

At this point, it is interesting to reflect back on the girl Wendy inventing ways to teach her young brother to use those parts of his mind and body that had been so traumatically impaired. Applying what she learned in that situation of intimate dialogue, the artist Ewald has attempted, again and again, to articulate and integrate marginalised parts of the social body by educating those parts, via the reflective processes of word and image, to observe themselves then record and display those observations. Thus has Ewald's art evolved to embody the multi-lateral, dialogic, subjective praxis described by the educational philosopher Paulo Freire in his *Pedagogy of the Oppressed*.

Whether I am teaching or photographing, the crucial part of my artistic process is human inter-action. What is it, finally, that I am doing? is it some sort of visual anthropology? Is it education? Photography?

Can I combine these elements and be an artist too? If we accept the definition of anthropology as an "investment in social portraiture", as a mode of sketching life in all its complexity, then Ewald is an artist in an anthropologist's skin. It is this tension in the work that makes it categorically slippery. "My work is documentary in that it deals with the real world and certain real experiences and impulses yet, in a way, I conceive my works in terms of models for others to use, rather than as ends in themselves."

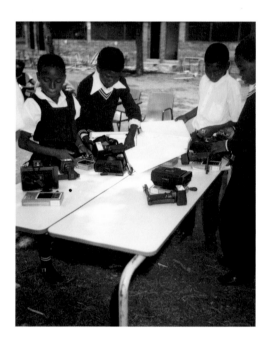

Ewald's last comment reveals affinities with Joseph Beuys' mythic educational performances (which, interestingly, were grounded in the teachings of Rudolf Steiner, one of the most original and creative of elementary educators). Her performative models are the different communities of children she encounters at the same point in their cognitive development where the logic of concrete events makes way for the development of abstract reasoning. Like Beuys, Ewald views teaching as an open praxis, "a political act that enables people to

understand the powers that use them and the powers that they use".

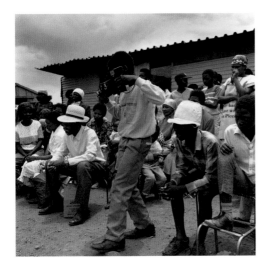

Ewald's unique oeuvre is founded on her enduring fascination and respect for how children see things. "All children have an ability to tell their stories in a very direct or revealing way. Their language is their own, and they don't censor themselves, so their observations can shift from sweet to violent in a moment. All human experience is present in each one of those kids and you can have access to that via the processes I employ — taking photographs, being photographed and arranging their things." Thirty-five years later, the world of Ewald and her children has changed dramatically, from the fixed communities in isolated rural villages that she once explored in detail to the contingent communities of the global village where she now freely roams.

Increasingly she finds herself responding to situations that are unstable, fragile and contentious, situations in which the rapid processes of change in growing children are matched by the rapid processes of change in local, national and global communities. Ewald continues to generate new ways of questioning and acting in the world, creating a memorable body of artistic work that carries with-

in it the traces of what Freire called "a pedagogy of hope." In working with others, she has learned to recognise what they are seeing, what kind of questions their vision asks of the world and how to allow their perceptions to surface with her own.

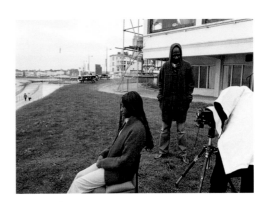

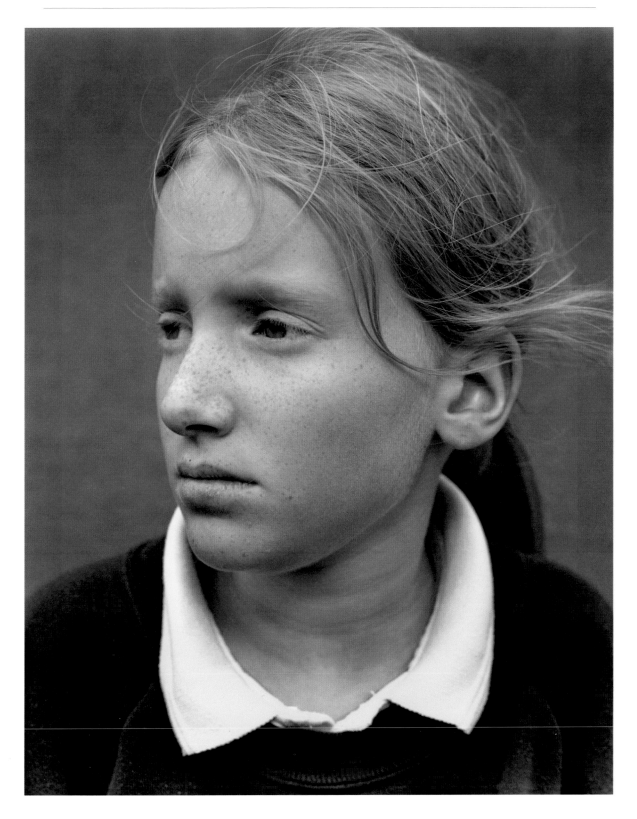

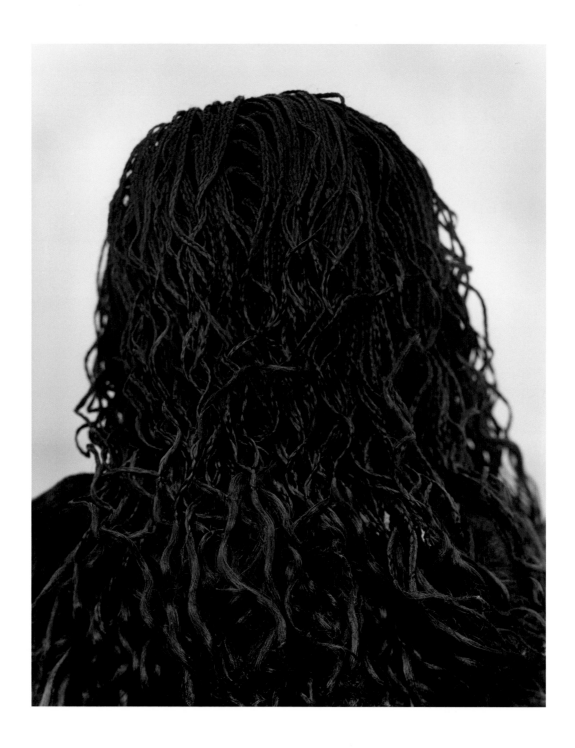

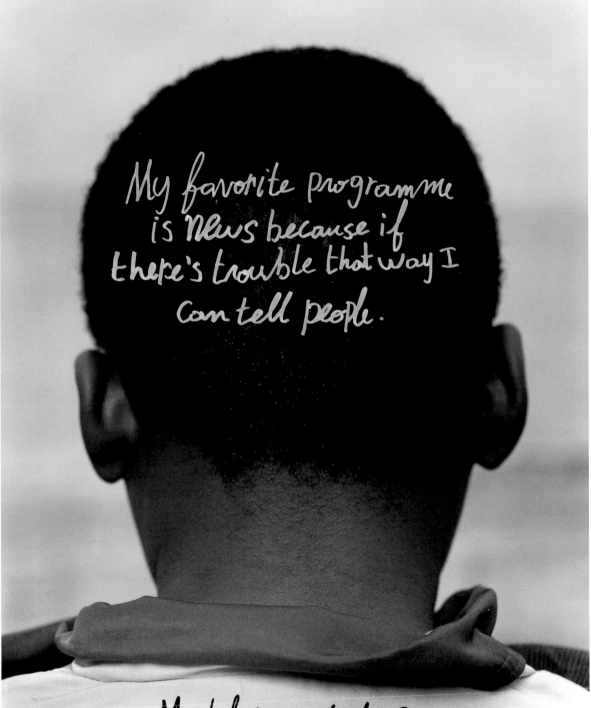

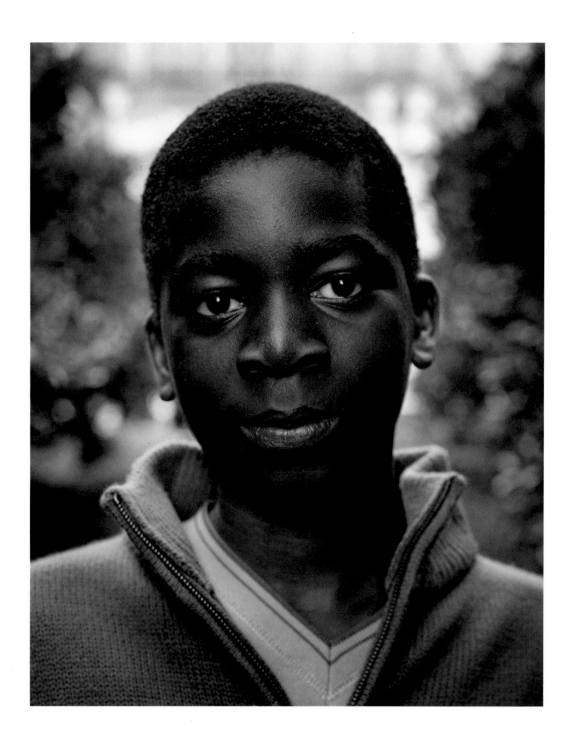

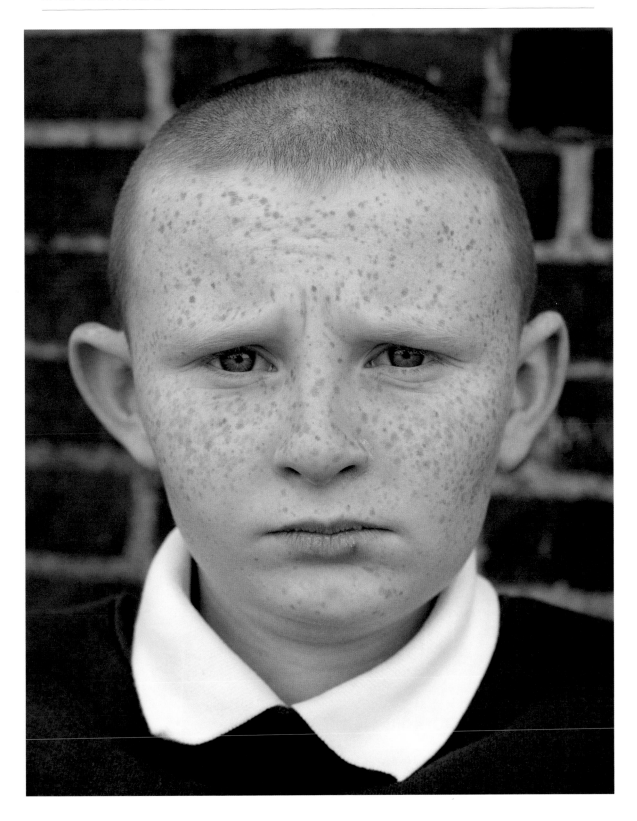

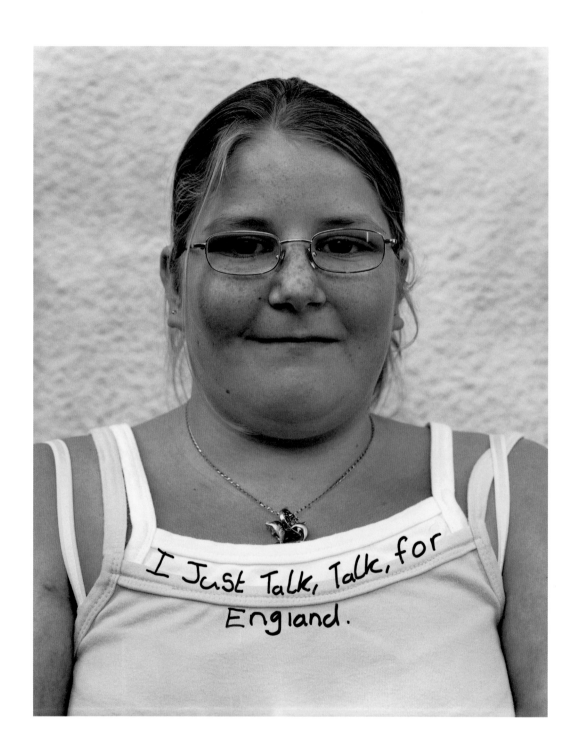

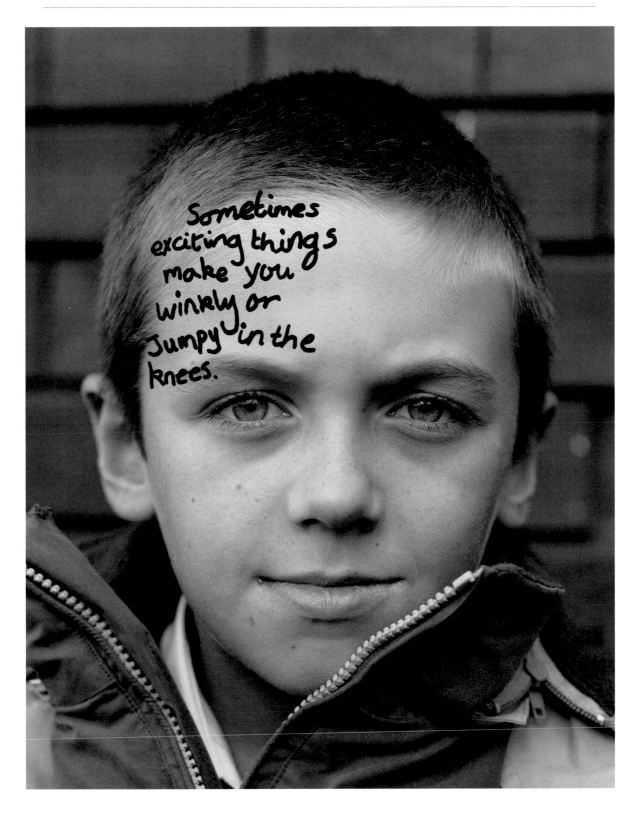

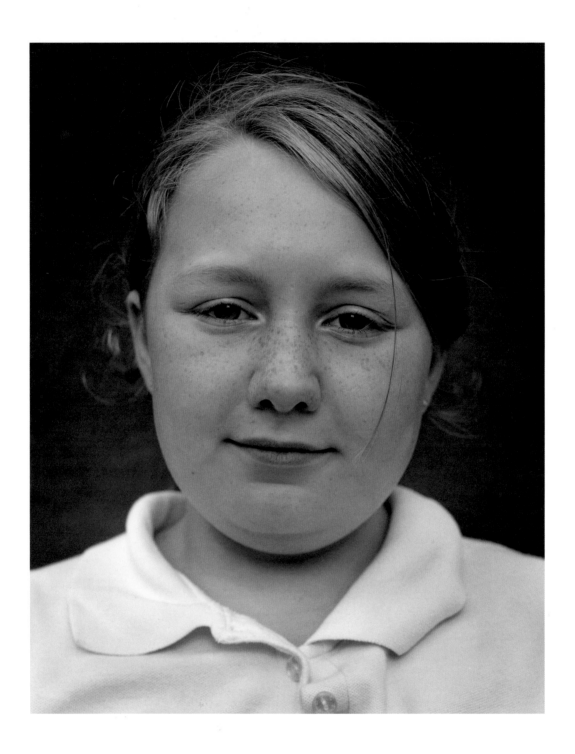

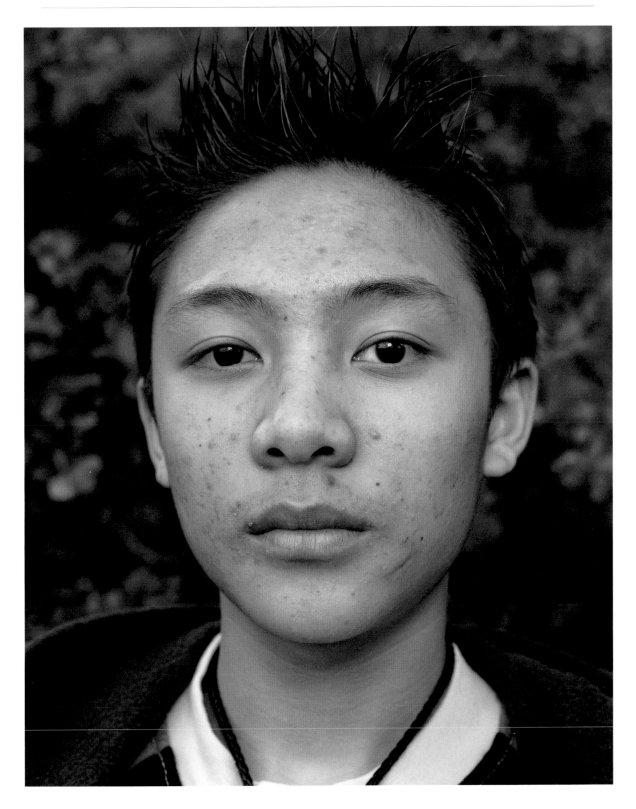

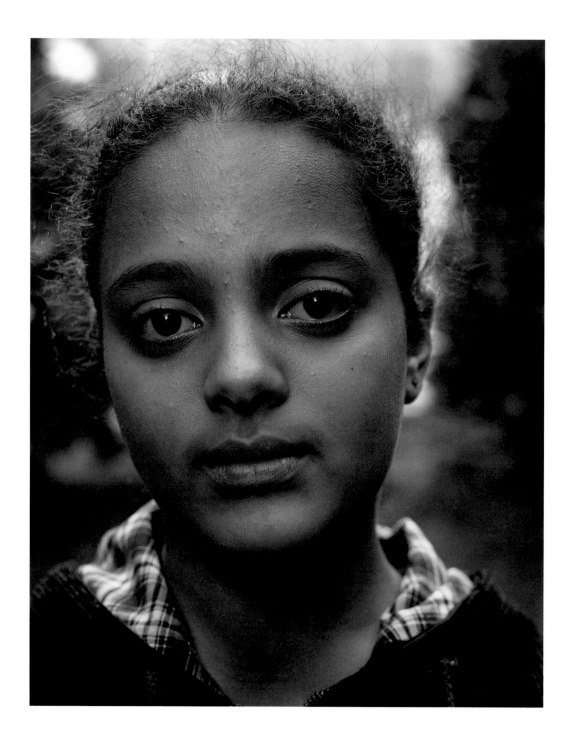

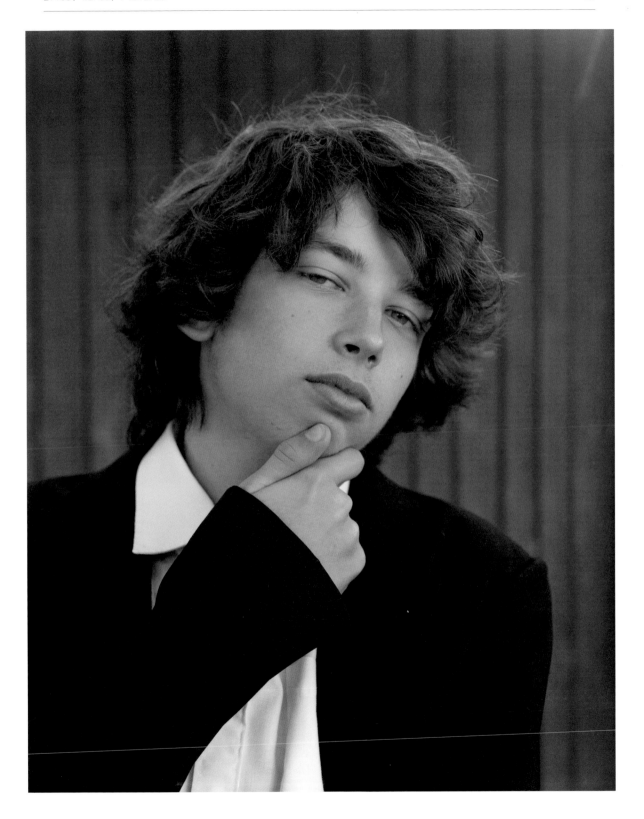

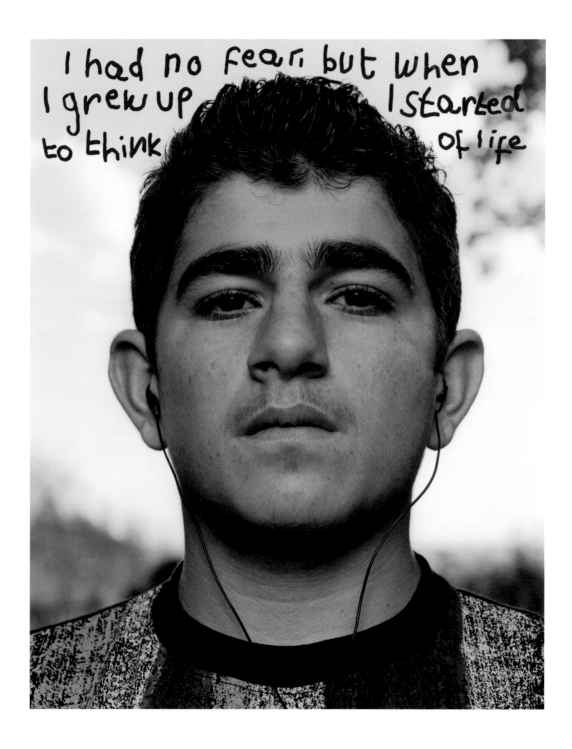

I had no fear, but when I grew up I started to think of life

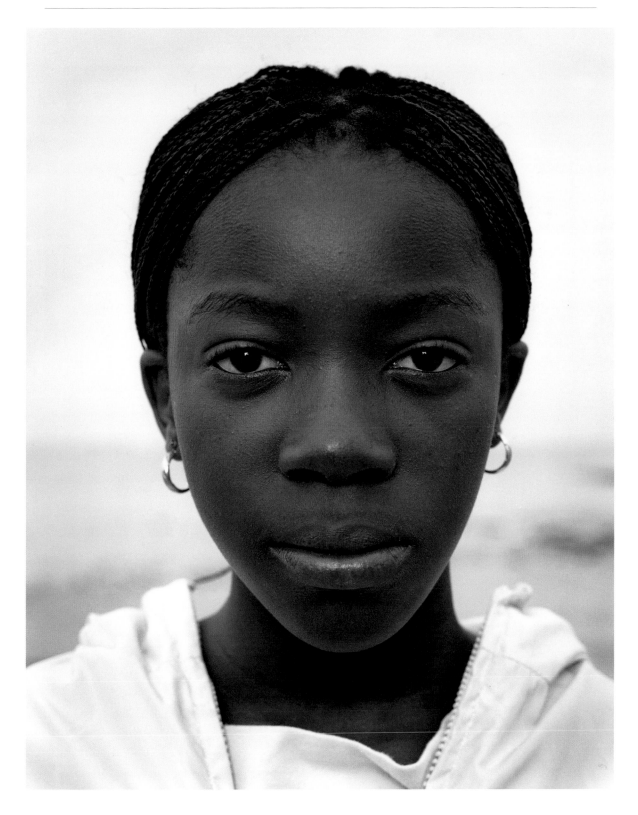

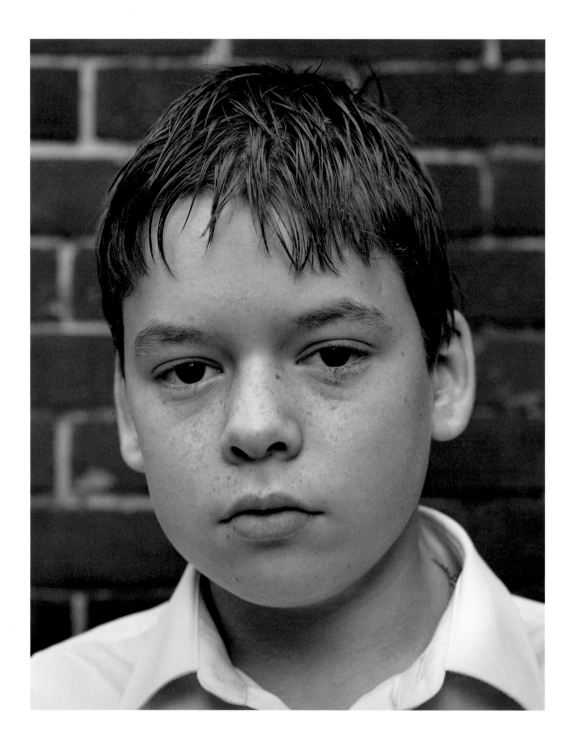

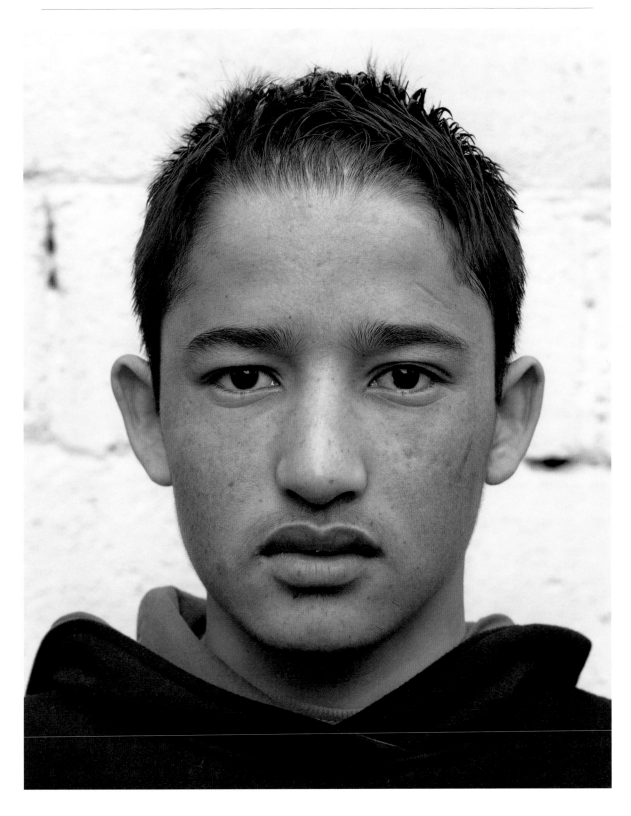

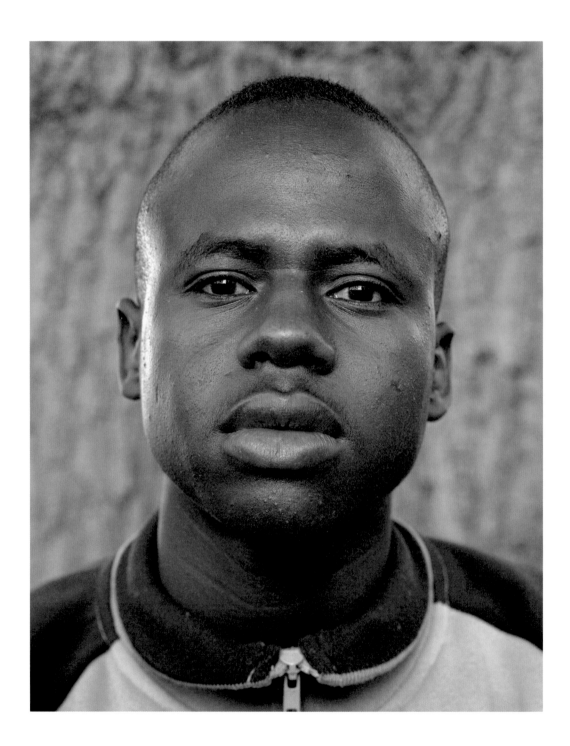

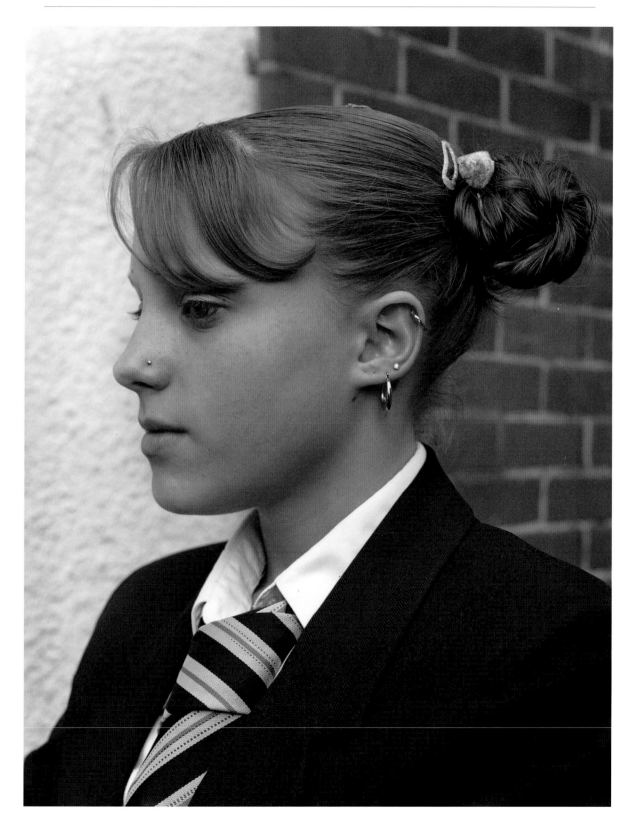

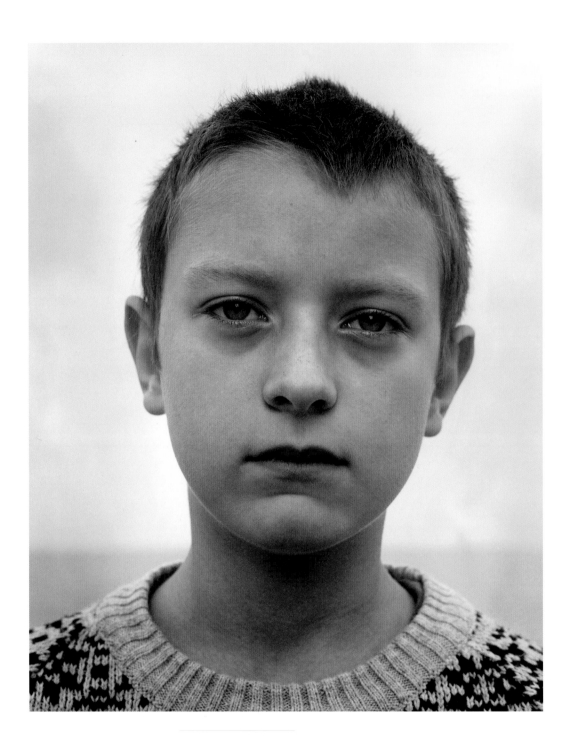

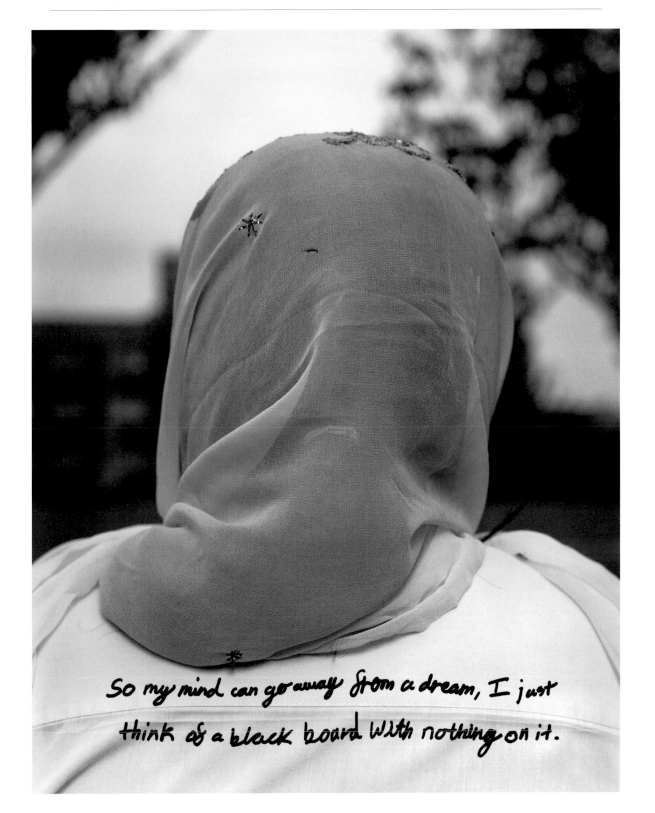

So my mind can go away from a dream, I just think of a black board with nothing on it.

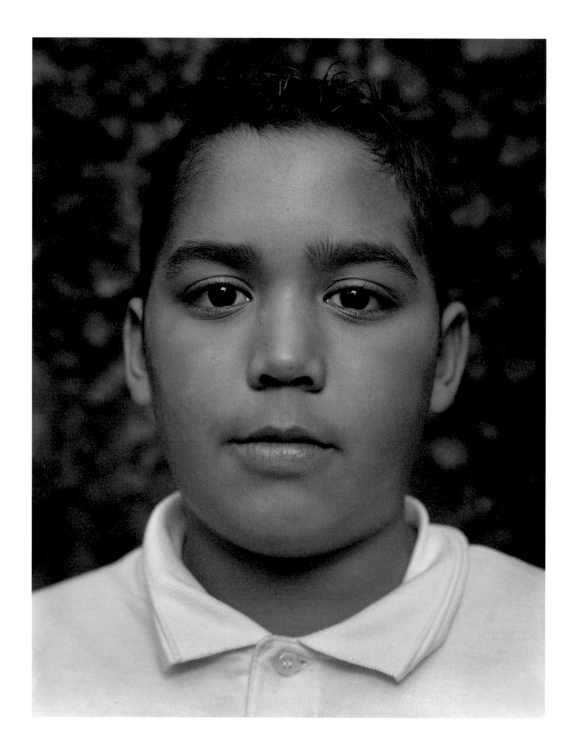

LIVES, WORDS, PICTURES

ASHLEA
BORN 1994, LONGFIELD; ARRIVED IN MARGATE 2004
LIVES IN MARGATE

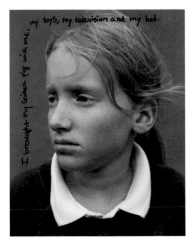
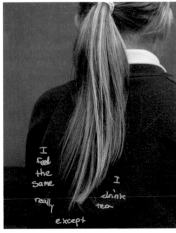

When I moved to Margate, we had two removal vans and two cars. We put all the big stuff in the vans and small things in the cars. My brother and I sat in front in separate cars. The motorway was straight and bendy and we were going fast. I was bored because I had no games to play. On the way we stopped at the petrol station, got petrol and Coke and salt and vinegar crisps. When I went to Cornwall, about a year ago, my dad got me a T-shirt that had five lines saying, "Are we there yet?" because that's what I always say on long journeys.

When we got here, we had to wait because the person who we bought the house from hadn't moved all his stuff out. While we waited we went down to the café at the end of the road. My brother and my dad moved the stuff in and I chose my room. Then I unpacked all my stuff and my dad put my bed up. I played on my Playstation while my dad and Carole went to get tea.

I'm from Longfield, near Gravesend and Dartford. We left because there was nothing to do there. I was excited about Margate because of the beach and the big house. I thought Margate wasn't very big, but there was loads of people. The people are nice. They all say hello to you and stuff.

I brought my guinea pig with me, my toys, my TV and my bed. My guinea pig's called Buzz and he's big and different colours. In my old house, I had a really small room, but now I have a really big room. It has purple and pink walls, purple carpet,

purple curtains, a pink wardrobe, a big fireplace and a sink.

I am ten. My birthday is on the fifth of February and my hobbies are football, tennis and I like playing the Playstation. I'm a tomboy. That means I dress like a tomboy and do stuff like a boy, like playing football. I have two footballs. I got one from Aldi's shop and the other one's my friend's. He left it here when he kicked it over the fence.

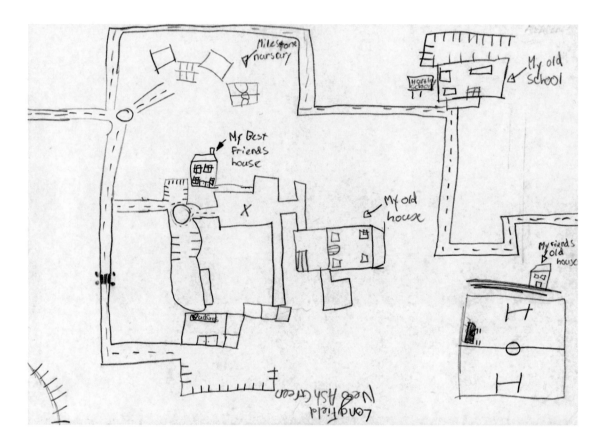

I've got a kitten named Cleo and I'm going to take a picture of her and my guinea pig Buzz. My favourite place to go on holiday is America. I'm going there next year in March for three weeks and one day. My favourite food is salad and pizza.

My family is me, my brother, Carole and my dad. I don't get on with my brother very well because he's annoying. Carole's the person that looks after me and lives with me. My mum died three years ago. I don't know how old I was. About six, I think. Her name was Kim and she was nice. I miss her.

I'm afraid of spiders and I don't like the dark. I'd describe myself as annoying. It's just what I do. Annoy my brother and everyone. I'm kind too. I do stuff for people. I help do the housework at home. I help with dinner. When we have a roast or salad, I do all the cutting. The worst bit is cleaning my room.

I never think about the future. I would like to be a football player and play for Girls Man U as a defender. I'd like to have a big house, nice big car and swimming pool. When I shut my eyes, I dream about my holiday in Florida.

I think people move to Margate because of the beach. There's lots of stuff to do – the arcades, go down the shops, the penny machines. Yesterday, I went to the Lido sands with my dad, Carole and Dean. We caught seventy crabs and last week we saw a seal too. I like the beach best.

I was worried when I first moved here that I wouldn't have any friends. I thought no children would be living in my street. But there are a lot. I miss all my friends back in Longfield, but I've made loads of new friends. I feel the same really, except that now I drink tea.

CELESTE
BORN 1997, DEMOCRATIC REPUBLIC OF CONGO; ARRIVED IN MARGATE 2004
CURRENT WHEREABOUTS UNKNOWN

 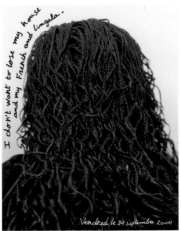

People fight everyday in Kinshasa because of the cars. All the time. They don't know how to park their cars, (they) even park their cars on the road. I didn't play with the dogs at home. I'm scared of them. I played with Barbies. I liked gymnastics and French. I didn't like English. It gave me a headache. I don't know why. I couldn't answer the questions. I think I'll learn it now. I don't want to lose my house and my French and Lingala. Our school was medium-sized. Church is not the same thing. It's big there…

I thought it would be beautiful here and safe here. I'm scared of bandits. I'm afraid of the police. Everyday there are police that pass by, always, "eee oow eee oow eee oow eeeoow". There's no space for playing here.

(Translated from the French)

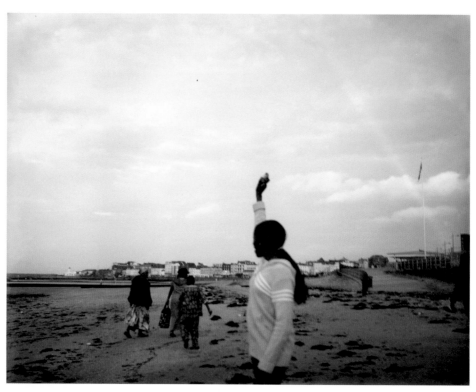

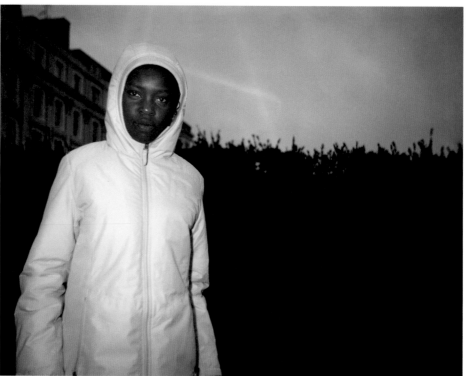

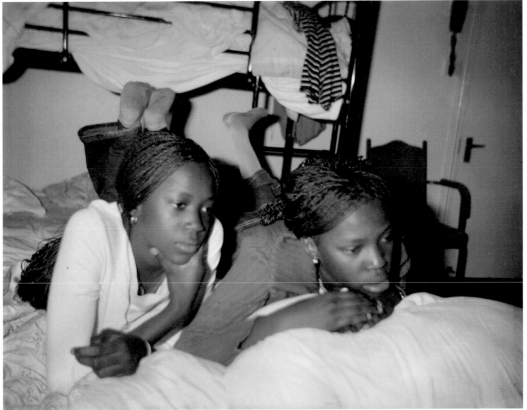

CHRISTIAN
BORN 1995, DEMOCRATIC REPUBLIC OF CONGO; ARRIVED IN MARGATE 2004
RESETTLED IN SCOTLAND

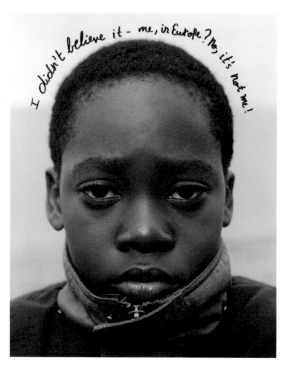
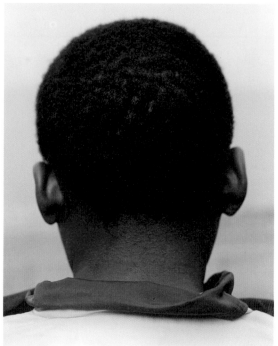

We came from Congo on a plane. We left because there is a war in Kinshasa. We left my cousins, the house and friends. I brought nothing... well, a little bit. It was just me and my mum. The journey wasn't good, but I liked the plane. We always fastened our seatbelts and in the window it made clouds.

When we arrived, I saw the airport with lots of planes. And it's not like that at home. I didn't believe it. "Me, Christian, in Europe? No, it's not me. Is it true? It's me!" We were put in a bus. The driver told us that the hotel that we were going to would be nice, but it wasn't there. He went to another hotel and everything was closed. I thought that he was lost because the other place was only a house. Then he turned and brought us here (The Nayland Rock Hotel).

The first day when I went out, I saw the beach. Then I dreamed that I was playing with a ball on the beach.

Our house in Kinshasa was big and we had two cars. There were two sitting rooms, one for children and one for adults. Me and my mum lived there with the rest of our family, my dad, my two brothers and two sisters. I remember my brothers and sisters. I played with them. Sometimes they taught me things, like how to ride a bike, and games like bits — they're called 'puzzles' here. My father, brothers and sisters have all disappeared.

Kinshasa is not good because it is unsafe. One day at school the kids were throwing stones at the soldiers, and there were bullets in the air. Some students were killed. The students who were against the president wanted to come into school to loot us. It was then that the U.N. man threw a gas bomb so they couldn't take us. My mother couldn't come to get me because they were wrecking cars in the streets and throwing stones, so she sent her cousin instead. I didn't feel good. I didn't want to go back to school after that.

I still remember the day they arrested my father and gave me some slaps. After, they cut my big brother's head. I was scared because soldiers were killing people. I thought they also wanted to kill me. My mum and I escaped.

England is a country I like. In Congo, there are only Combis and broken taxis. I had seen double-decker buses in photos. I wanted to see them the most, I think. And when I got here, I asked myself, "How can it be that the buses that I've seen on telly are passing me like that?"

I remember seeing the Queen's house. It was big. There's also Queen's Park nearby. I haven't seen the Queen's guards yet. Does she have a castle in Margate too? Does she have houses in other parts of England? Does she sleep in all of them? When she goes out, do all the cars have to stop? In Congo, if the president or even the ministers go out, you have to stop and get out of your car.

Maybe the Queen would like to see me close up. The soldiers won't do anything if there's a very little boy who goes over to the Queen's castle. I've seen the soldiers throwing gas in the courtyard of the Queen's place. I saw one with a red hat and another with a black hat walking as if he was counting how many footsteps he had to make to get there. I counted his steps until the Queen's room. He had a cross on a stick. He hit the Queen's door twice with his stick, and when no one answered, he knocked. Does he hit the door like that because there's a problem?

There was also something I saw that turns in a circle [The London Eye]. If you go up there maybe you can see all of London. I didn't see how it turns, but I can see that there is water at the bottom. Maybe you go to the bottom of the river? When it stops some people are very high up, so then do they have to jump?

Sometimes I dream I'm singing. Sometimes I dream I'm dancing. I dream that I am grown up and speaking English. I dreamt that I was eighteen. It was the day of my party. All my friends came. During the party I heard someone knocking on the door.
I opened it and saw my brothers and sisters. They were older. My mum was sleeping. I tried to call her. My mum managed to wake up and change and then she went to their house. I only dreamt it the other day. I want to dream about it for a long time.

I like taking photos. It's going to give me memories. I'll have good memories of Margate because it's a nice town. There are no problems here. It is safe and everything works well. Everyone goes shopping and does what they want. I want to stay here. The people of Margate find me nice because I'm polite and I respect them. But I don't like it in the hotel because there are so many people.

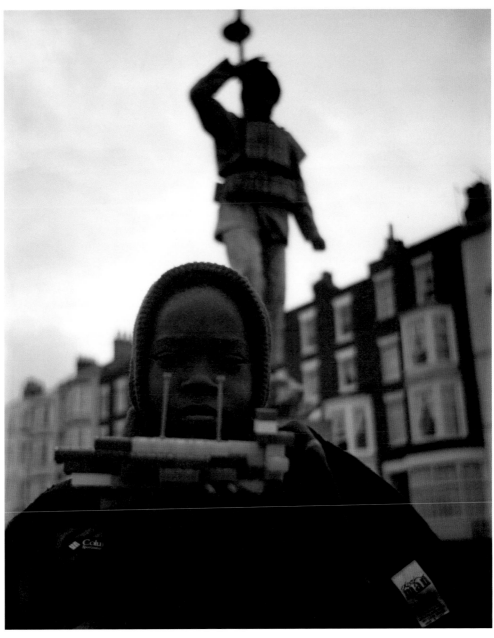

I always play Nintendo and Playstation. We go to the Galaxy. But if we don't have the money, I stay and play Playstation. Sometimes if we go out I can take my GameBoy. I can't play in the car because there isn't a way to connect the television. My favourite programme is the news because, if there's trouble, that way I can tell people about it. Sometimes I watch it around four o'clock in the morning. And I watch my cartoons at four o'clock in the afternoon. The cartoons also show me how to speak English. I like the cartoon Peter Pan a lot.

I think, now that I'm here, I have to change languages. If I study, I will try to learn English. I need to speak it. In Congo, I wasn't well, I didn't feel comfortable. I want England to bring safety. I want the English to bring security to Congo, because, if the Queen asks the President of Congo and the President accepts, they can sort out the country, the houses, the roads, the laws, the taxis. And make all that easy.

I want to study and, if I finish, I'd like to work. I've always wanted to be a banker. My mum and I would have a beautiful life. And we'd have a house. And maybe one day we'd see my brothers and sisters.

(Translated from the French)

ELISIO
BORN 1993, ANGOLA; ARRIVED IN MARGATE 2004
RESETTLED IN NOTTINGHAM

I was born in Bengo in Angola. Coming here to England was my second time on a plane. The first time was to get out of my country. I felt a bit sick. The first sensation when I arrived was of the stairs. The stairs were rolling on the ground. I liked the journey very much. I've always wanted to learn new languages and travel to other countries. I imagine I will make new friends, play football and have a video game console. That is what I hope for, and a house and safety — to feel safe.

I'm afraid of heights and snakes. I want to be a petrol engineer and a football player. I'd like to play for any team, as long as I play. Ronaldo is my favourite player. He plays for Manchester. And the English captain, Beckham. I'd like to go to a match with Chelsea and Manchester. Manchester would win 2–1.

The first thing we'll remember here in Margate is this workshop [with Wendy]. It's a big adventure. It's good because I can take photographs. I like to see people standing there, laughing. I like it very much. It's a way of recording memories. In Angola, I took pictures of my classmates, my friends, my mum, my family.

We came with Mr. Rodrigues. We didn't know him before. Someone delivered us to him. And he pretended to be my father. He handed in the documents. We just followed him. We didn't say anything. We didn't bring any bags, only little packages, because we had escaped. I brought two pairs of trousers and one T-shirt. I left everything — my father, my brother, my sister, my nephews, my house. My eldest brother is hiding in the forest. I don't know if I will ever see him again.

I don't know how people will see us here. I just hope they don't see us as strangers. There was more sand in our country than anything else. The small TV in the room here reminds me of home. I shared a bedroom with my brother. It was small, similar to the one we have here. I've forgotten almost everything. We played video games. We used to play football but on the video game. I like watching TV here and playing football. I played on the beach with some boys from the hotel. We were just

having a kick about. In Angola it was in the fields. I'd like to go to Manchester to watch the games.

At school I had many friends, but I liked sitting on my own because I could learn more. My teacher told me I was one of the best students, because I used to sit alone while the others were always playing. I learned English, because I've watched many films. There's one where a man has many friends but they are bandits. His life is a TV series. It's really complicated. There's one part of the film when he is sleeping. After that there's a part when he's crying and all the people who are watching him on television start crying as well. And he meets a friend and she's his friend but she's an actress as well.

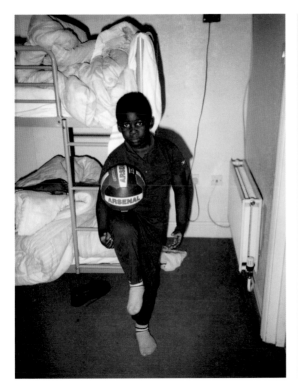

I'm happy that I will change. I don't want to lose my intelligence. I'm hoping that the change will be for the better. I don't want to give up our food, *funge*. It's a special food made from ground cassava. We cook fish or meat with palm oil. After that you make the *funge*. It looks like mashed potatoes. I would help my Mum make that and especially cakes. When my mother made a chocolate cake, it was very good.

In Angola, our school was small. The teacher was good and I was a good student. The teacher explained well. After the class, we bought some snacks, played football. My classmates and students from the other classes and I usually played without anyone noticing. There was a reception desk at the school and we could hide ourselves behind it. Sometimes, we would play at each other's houses after school. We would play mostly in our own gardens. Occasionally, I would go to my friends'

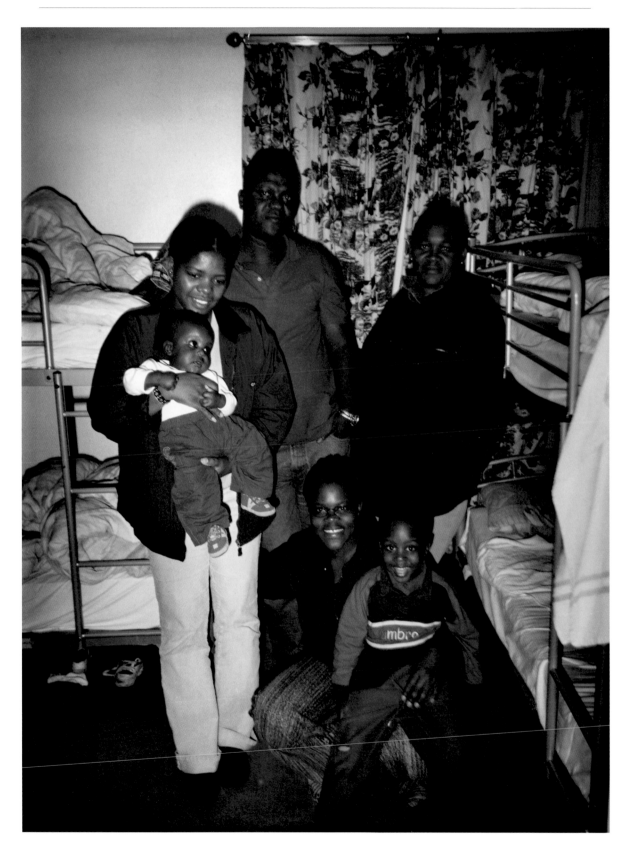

houses and they would go to my house, because all the gardens are huge. I had one friend living in a big house, with a garden to play football. He was rich. There was a gym in his house where we did weights. His family was one of the richest in the city. We watched films. We played hide and seek together. I didn't like to play hide and seek. I don't like to run for no reason.

I'm not a little boy anymore. I'm aware of what I'm doing. I am well-behaved and I have a good head. My mum doesn't need to complain about me. What I want is not always good for me. My parents have more experience than we do. They are the ones who must say how I am. I don't agree that I'm good at everything. I'm not good at catching snakes. I like playing. I like listening to music. I like to watch animal programmes, films, soap operas. I used to play video games.

One day my mother left some oil in a pan on the stove and it caught fire. I was very small, but I put the fire out. I knew how to because I saw it on TV. I don't remember when, but I like to watch programmes in which you learn something. I used to do this kind of thing a lot. One time, my dad left the beans on the fire and went to a petrol station. When I arrived there, I smelled the gas escaping. The food was really burnt. So, I went there and turned off the gas. The fire was over.

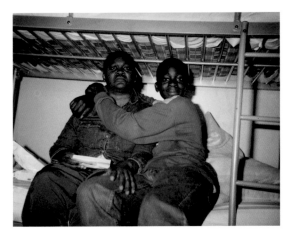

You have to work really hard when you're older. You have a lot of worries. You have to work a lot to eat. You have to be patient. Being younger is about playing and nothing more. To play, to study, to play anywhere. Nothing else. I have to take care of my younger brother Miguel and my mother. When I have to punish Miguel, I do. (It's when he's done something wrong to me, not my mother. I don't want to do that to my brother, but I have to). If I don't punish him, he will carry on with his bad behaviour. My heart isn't happy with that. I must do it. If not, he won't respect me. I have to remind my mother about the medicine she has to take every day. I have to put the eye-drops in her eyes every day. My mother says I am man of the house.

(Translated from the Portuguese)

GARETH
BORN 1994, BELFAST; ARRIVED IN MARGATE 2003
LIVES IN RAMSGATE

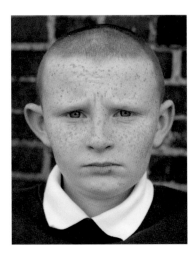 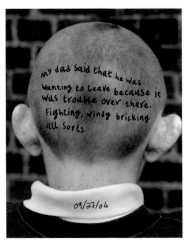

My dad said that he wanted to leave because it was trouble over there [Belfast]. Fighting, 'windy bricking', all sorts. My aunt Donna moved here when she was seventeen. My dad said to me, "Gareth, do you want to move to England?" My brother and sister didn't even get asked. I said yes, I wanted to leave to get rid of all the trouble, to have a better life.

Belfast was trouble. The Fenians even smashed me and my brother's room, the kitchen window, and they even threw a petrol bomb into the backyard with my dogs in it. The Fenians are people with a flag — green, white and gold. They just want to make trouble. Kids were beating up people like my brother, my cousins, beating up my mates. My dad couldn't do anything about the boy who was beating up my brother. He was a bouncer and he threatened to burn our house down. He would give us a chance to get out and then burn everything that was in our house.

For some reason three men came to my house and said we had to go up to Lisburn. So my granddad took us up there. We slept for a couple nights. My mum asked me where do I want to stay, Lisburn or Belfast, and I chose Lisburn. There were no Fenians in Lisburn to smash the windows, but there was one man who took people and went round killing people. He used to run round places just grabbing people and putting them in a black bag, putting them in his van, driving down to the River Lagan and chucking them in there. We all called him 'Freak'. My sister saw him once and he said to her, "I'll be back for you".

When we left Northern Ireland it took eight hours on the boat and then six hours by car. It was very boring. I fell asleep on the boat. I woke up at my aunt Lorna's, just down the road.

I brought with me a Red Hand of Ulster flag. It's a red hand, a five-pointed star and a crown with diamonds on it. The hand's red because it's got blood on it. King William was in a race and his hand got chopped off. I brought a Liverpool scarf and a Rangers scarf, almost all my toys, my Liverpool pictures, my biggest medal, the Queen's Jubilee medal.

I don't feel much about Margate, but it is better than Lisburn and Belfast. There's no trouble. There's no Freak. When my cousin went fishing once down in the river Lagan, he thought he caught a fish, but he didn't. He actually caught a black bag and there was a dead body in it.

The people in Margate are fun. They're just like people from Northern Ireland. Good friends, good pretend wrestlers, good runners. Margate and Northern Ireland both have the Union Jack. It's red, white and blue. It means nothing really to me, nothing like the Ulster flag. I don't want to lose my flag because it will always remind me of the people who live over there.

I just don't really fit in here. I feel at home in Lisburn and Northern Ireland. It's where my family is. The accent's different in both places. Here they just speak normal British English and over there they speak Ulster British. In Belfast, no one says, "What did you just say, Gareth?"

When we arrived, I saw all different colours. I was just happy because at least I was going to see my aunt Lorna more often and my cousins and my uncle Dale. I thought it was going to be fun, all houses, all trees, cars, vans, buses. I imagined I'd get out to play instead of getting grounded for being bad.

I left behind my family and my best mate. He's called Gregory. He was just the best person who I could ever have as a brother, because he let me go around his house. He walked to school with me. We only had a bit of a fall out a couple of times. He invited my family to his party. It's a really big one and they just have fun. I don't call him now. My mum can't seem to find her book with all the numbers in it.

My Dad doesn't have a job. We don't do anything really now because there is nothing to do in Ramsgate. We live in the town centre. There's a car park beside us, but my dad doesn't really want to go out. Whenever I get grounded, my brother and his mate are going out playing, doing all different sorts of things. At school, I'm having fun. At home, I'm just bored.

I think I'm sensible, and I'm a bad, annoying, naughty, grumpy little boy. I can be nice in school and sometimes at home I am a bad child. I beat up my brother if he hits me once. I call my brother and sister names. I never stop talking.

I think people think I'm an okay person to play with. People like me — all my mates, nearly everybody. My uncle Dale even likes me, but sometimes he hurts me for a joke. I play with my two cousins, Chloe and Crystal, and I just muck about with DJ, the baby.

I want to be a copper or a fireman or a bouncer. I like sports and watching TV and eating doughnuts and bananas and drinking lemon fizzy juice. I like playing British Bulldog. You get lots of people together and there's one person up at one end

and about fifteen people at the other end. One person stands there all alone and says "British Bulldog!" And the others all have to run up and try and get past. If a person is caught, they're It.

In the future I want to move back to Northern Ireland because I just miss all my family over there. Sometimes my cousin Joanne phones up. I've only talked to my cousin Dixie twice. My dad doesn't want us to move back. But hopefully he's going to try and get us over there for holidays.

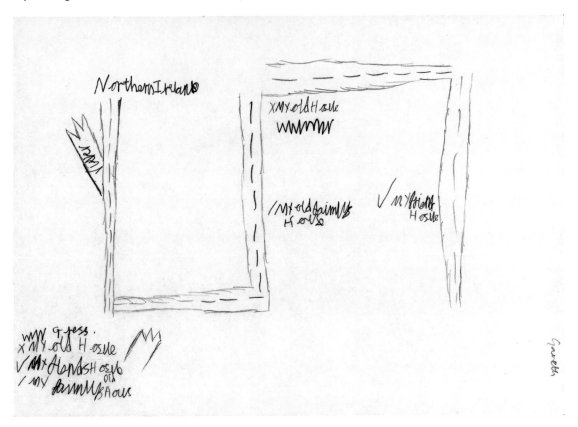

I had a dream about moving back to Northern Ireland. In the dream I am with my uncle Stevie. I was crying and so was he, and I felt the tears coming down out of my eyes. I had a daymare. I woke up in the morning and then I fell back asleep. I had a dream that a bomb hit England, Kent, Margate, and the place flooded. My mum, my dad, me, my brother and my sister were all in the car. And I think we died. Then I told my dad and he said, "Ah, you'll be alright".

GEMMA
BORN 1991, LONDON; ARRIVED IN MARGATE 2000
LIVES IN MARGATE

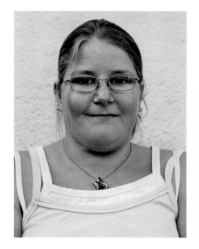 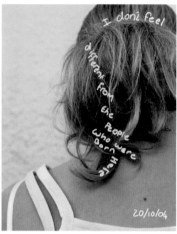 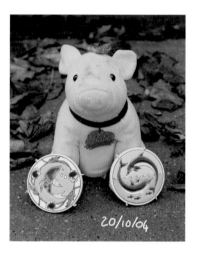

We left London because it was too rushed and busy down there. My mum had just had enough. It was four or five years ago. I was seven. We moved to Margate in February. I brought a teddy with me that my mum won at bingo. She won two teddies and gave one to me and one to my niece. We wrote our names on them.

The journey takes about two hours, but our car broke down on the way. I fell asleep. Me and my niece, my mum and dad and some children stayed at my auntie's flat that night. We woke up and I was really excited because I was going to see the house.

First we walked in the door and my mum looked round the house and she went, "God! You can have the house. I don't want it now!" Everything was piled up in the front room. My dad had to put it all away and sort it. My brothers and sisters helped. They were trying to put up the bunk beds, so my niece Kerry Ann and I went in the garden. The grass was really long, because no one had lived there for ages. We went looking for grasshoppers.

My mum was about ten in the sixties and my dad was eleven. They've been married for twenty-seven years and they knew each other before that, because they lived quite close to each other. My mum had my sister. She's now twenty-seven. Then she had my brother, who's just turned twenty-six. Then my sister, who's twenty-three and my brother, who's twenty-one. And they all had children. I've got thirteen or fourteen nieces and nephews. We grew up in the same house. I'm really close to them. We don't go around much because my dad and mum work, although she just got over asthma. When I was born, I had a different mum. I don't see my other mum and dad that much. They live in London. And they've got loads of kids. They come down on birthdays and Christmases. I think about them as a mum and dad, but they're more like an auntie and uncle.

My dream is that all my family are safe and happy. My family means loads to me because I love them all so much. I'd love it if they all moved down here. Then we can all be together like we were in London. Sometimes when they drive down to visit they don't ring until they actually get to the bottom of the hill. They say, "Put the kettle on!"

I've got two sides to me. One that you love to see, and one that you absolutely don't. When I'm in the mood for being happy, I'm just happy all the time and I just dance around being a prat. When I'm not in the mood, I just sit there all glum. When I get the hump with my mum, I have a go at her. I don't like it. I always say sorry to her. She comes over and gives me a cuddle.

I thought it was going to be good and fun in Margate. I went to Northdown School because it was the closest. It was fun, but some girls started bullying me on the way home from school and in school, calling me names and being nasty. Then one girl started pushing me, so I pushed her back. It was really horrible. It didn't change the way I felt about Margate. It changed the way I felt about the girls, obviously. And it changed the way I felt in myself. I felt really small and hurt in that way. I took some time off until it had been sorted out. We applied for Hartsdown, but they said they didn't have any room. I waited for nearly a year. I helped my mum and read books and went to the library and stuff.

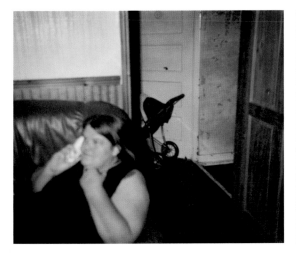

I've gained by coming to Margate. I've gained more trust with my friends. In London, my mum really didn't like me going up to the main road because my older brother got run over. So I could only play with my niece.

I don't feel different from people who were born here. Margate is full of tourists because of the sea and the cave and the Dover castles. There are asylum seekers. They come into the country in vans, smuggled into the country because of the wars and stuff. I think the Prime Minister in their country should sort it out and say, "No. We're not having wars!" so they can all go back to their country. So they can live

happily, and we can live happily in this country, and Spanish people can live happily there. Even though there's nothing wrong with different skin colours, it just causes loads of arguments.

There's one coloured girl in our class. Everyone picks on her because she comes from Iraq. I know there was a war between Iraq because of the Twin Towers and stuff. I know they're kidnapping people from England and America and killing them. I was glad it wasn't happening in this country, but I was sad because of all the people who were dying. People shouldn't do things like that because we all have to live. If I personally killed someone, I wouldn't be able to live with myself. I'd have to die myself. I wouldn't be able to cope.

I think racism is stupid. We're all the same. We're all people. Just because we've got different colour skin and live in different parts of the country, people think that's bad. I don't. If you live in a different country, it's *your* life, not *mine*.

My friends call me 'The Happy Woman'. I'm always happy when people come. I just talk, talk, talk, talk for England! You ask people a question and they tell you their viewpoint and then you think, "I've got a completely different point of view of that!"

I don't know what I want to be when I'm older. I want only two children, a boy and a girl. I'll dress the girl in little frilly things and the boy really smart in Gap and stuff. I was thinking of being a chef, a plumber, but I don't know. There are too many things to choose from. Whatever comes.

A map of my life would just be a happy spreadsheet. There would be a tiny fraction of sadness from when my nan died. She used to bring me little blue soft mints. The map would be a lovely heart shape. I'd cut out the people that I don't love, like the bullies, so there'd be little holes in the heart.

GLENN
BORN 1994, DERBY; ARRIVED IN MARGATE 2004
LIVES IN MARGATE

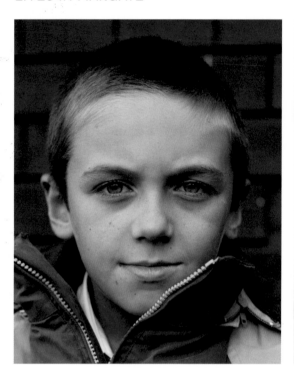

october 1st 2004

I have been here three months and I have had a steady life. When I left our house, everything was packed up. It looked empty. I thought I was going to miss it, but I don't. It was a really nice house, but in the end I just forgot about it. We packed for about three days. We had a lot of stuff. I brought all my video games. We brought our computer, all my giant dinosaur or monster figures. Loads of other things. We packed it all in the big truck that my dad's friend hired. I was in the truck with my dad and his friend. My dad's friend was driving it, I think. My mum and sister went in the car. I didn't actually see much because I was playing with my video games.

We only left behind a house and my friends. I didn't actually say goodbye to them. I said I'd send letters and we'd keep in touch, but I haven't had much time until now. I had about fifteen or twenty friends — a whole group. Then it dropped to just two because I got more interested in electronic and computer things. Here I have about five friends. When I arrived here I settled in about a day because I made friends really quickly.

It's like being an alien. You land on a planet and you don't know everybody. I belong here at school, but not that many people know me outside. Whereas in Derby, when I walked around everyone knew me. That's the difference.

Here, they don't think I have strange hair colour. They just think, "Oh, he speaks differently". My accent is different because they say "up" and I say "oup". That might

change because I'm getting more used to it now. I think the only other thing that will change is my hair colour over the years. It'll keep changing colours and colours and colours with age. When I get to OAPS, I'll get grey hair.

We left for family reasons mostly. We never got to see the rest of my family much. Margate's also a bit closer to my dad's friends because they live in London. My mum has two friends down here. One of them owns an animal sanctuary and one of them works in the theatres, like the Winter Gardens. We used to go to Kent on holiday. But now we never need to go on holiday because we're right here.

I was born in Derby. My sister was born in Nottingham. My grandma lives at St. Peter's Care Home. It's quite nice. It's just some old ladies keep coming really close, which gets sort of freaky. My grandma is very friendly, a very nice lady.

Derby is a crowded, cloggy, broken city. Kent's got more fresher air. There's only one thing I miss – the shops, as we said when we first came here. When I didn't want my games anymore, I used to get a bit more money for selling them. Here I only get eleven or twelve pound, whereas in Derby I used to get about fifteen or twenty.

Our house in Derby was quite big. It was a very nice house. I never got scared – not in this house either. I'm afraid of amphibians like frogs and so on. Lately, I'm afraid of ten thousand cockroaches squirming around me, because we went into an insect wildlife park somewhere more north or a bit south. We were in the butterfly park and then we went through a secret sort of murky, foresty thing and it had Komodo dragons and everything. There were about ten thousand cockroaches squirming on a big log in one tank. It was very spooky.

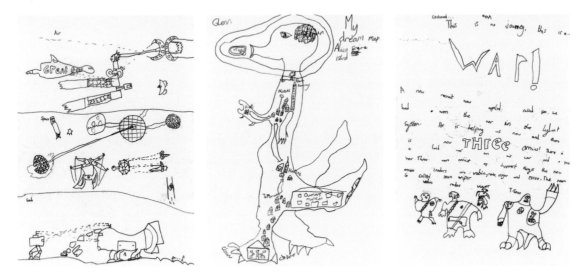

Nothing is the same about Derby and Margate. Here there is a beach. There are parakeets in here and it's a lot warmer here. And I can get to France quicker. I like Margate a lot. It feels quite good, but it's getting more empty and less popular over the years. When my mum used to live here before I was born, it used to be very, very, very popular.

My favourite things are the amusements. There's one in Cliftonville that I like. If you go over around ten o'clock, when they have to shut, the 2p machine turns on and you get to win some prizes. I do that with my dad, my mum, my sister and one of my dad's friends. First we go to Burger King, or Kentucky Fried Chicken. Then we got to Bugsy's Bowling Centre, have a game of bowls, and then we go to the amusements. After that we go home.

I have a Nintendo Game Cube and a Gameboy Advance. I like Nintendo. The one game I'm getting today is called Pokemon Leaf Green. My favourite game I've got now is Super Smash Brothers: Melee. It's a sort of fighting game. I used to like playing football a lot when I was in Year Four but I don't really do that much now. It's like electronic things are bugging my life.

The older you get, the more you're known. The kids who have moved here are mostly just like me. Ashlea's in sort of the same situation as me. We both feel like we're aliens from a different planet. It just feels like it because we're both from different places.

Some of the people here are from different places, trying to get into the country without emigrating — kind of like stowaways. I haven't seen any refugees yet. I've just heard about them on the news: "Refugee has hit town", or something. I think they would look very sort of European, like people I've never seen before.

Some of the people from Margate are nice and some aren't. The nice ones are my friends. There's only a few not nices maybe because they're from a different area. It's harder to fit in here than it used to be, because even though Derby had less friendly people, I used to get on there. Everybody was just like me, nobody was different.

My dad's busy with the shop. My mum usually helps my dad in the shop. It's very nice. It has loads of glass, china, porcelain, very special makes like Royal Doulton and Spode. I'm mostly not allowed to touch much because it's all very fragile.

I don't have a dream for the future. I just have to go to sleep and find out. I want to go into the video games industry. I want to be the games tester. It would make me feel happy and I'd have a good life. If I'm going to do this, I'll have to go to America.

I can't remember many of my dreams because each dream wipes the last away. There's only one dream that is kept alive. My dream now is that we are as small as dots. The planet's still the same size. There are strange vehicles, space travel. People weren't people. Weird, weird creatures, mutants and mutating things. Very freaky. There had been a war and nobody won. That might happen. A war like that. It never worries me. Mostly exciting things worry you, don't they? Sometimes they make you winkly and jumpy at the knees.

LANNY
BORN 1995, WALES; ARRIVED IN MARGATE 2004
LIVES IN MARGATE

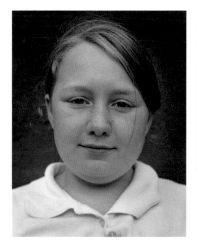

We moved up here from Troed-y-rhiw, Merthyr Tydfil, in Wales, so that my mother and my sister could have a better life. My mother used to cry in the bedroom. Even on Mother's Day she'd be crying, even on her birthday. But she's been a lot happier here.

I only knew we were leaving about five hours before we did. I was shocked because I had to pack all my things. We got a suitcase and packed it full of clothes. The only other things I brought up was a photo and a couple of Mr. Bean things. We only had a suitcase of toys between us because my mother wanted to get out of there quickly. We left all my sister's toys and most of my clothes.

We left because my mother's boyfriend kept being nasty to her. It was horrible for me because he was always shouting and if I wanted to watch a programme on TV, he'd just come in and turn it off. If my mother asked me to go up to the shop at six o'clock he wouldn't let me. He thought I was going to get away. I was frightened of him. He was a bouncer in all the pubs and clubs.

My mother met her new boyfriend when we came here on holiday. He asked her if she wanted to go out. She had already split up with her old boyfriend. So she said yes and they went out. We didn't tell my mother's old boyfriend because he'd go mad at her. In the half term, he's coming up to see my little sister. He's her dad. Then he's going back down again. My mother said he's allowed to see her as long as he doesn't start shouting or anything. But he has to stay in the B&B. My old dad just left me when I was about three months old.

My mother's new boyfriend came down all the way from Margate down to Wales. He picked us up. We were rushing around everywhere. We saw my mother's old boyfriend driving past on his motorbike. He didn't see us, otherwise he would have

swerved around and chased after us. We didn't get to Margate until one o'clock in the morning.

My mother's new boyfriend is good. He gives us everything. When I asked my mother could I go to the cinema with my second cousin, he gave me the money to go. And he bought me the ticket to see Busted, which was brilliant because Busted is my favourite band.

I didn't even have a chance to say goodbye to my two best friends in school. It was horrible. It was also my favourite teacher's birthday and I had a present for her. I stayed awake for the whole trip. When I arrived, my cousins were in bed. I hadn't seen my auntie and my uncle or my cousins for three years. I was talking to them and everything. I didn't go to bed until about two o'clock in the morning. It was brilliant to be in Margate so I could see all my family.

Margate has arcades that we didn't have in Wales. If we wanted to go to the beach, we'd have to go to Porthcawl, Barry or Ponti. It's colder up there in winter, but I liked it because we could cuddle up on the settee with a blanket and watch telly.

Some of the people are nice but some are a bit bossy. One day a little kid, about the same age as me, came up to me and pushed me. I just ignored it and walked away. It made me feel sad and unhappy. I just try to forget about it and carry on.

Troed-y-rhiw, Merthyr Tydfil, was only a little village; Margate is much bigger. I'm not even allowed out because I don't know the place very well. In Wales, I was allowed out at any time. We had massive fields and mountains and everything. You could go into a park, go through a gate and then into a field that was about five hundred miles long.

We had three houses in Troed-y-rhiw. The first was opposite a shop. It was really nice but then we had to move because it was damp. The landlord wouldn't fix the heater for us in winter. Our second house was lot better, but they were asking for 800 pounds a month. In Margate we own our house. It's good except for all the spiders!

Nothing scared me when I was living in Merthyr Tydfil, but a rat chased me. I had my foot on the wall doing up my lace, when I was on my way to school. It was dying. It was looking for meat, so it was running after me. I was faster than it, I can tell you that! It just died on the floor. It was running and then just went Plluuuuuuurrrrrrr!

When I was four I had a rabbit called Charlie. When I was on my way to school, I went out front, because that's where my rabbit hutch was kept, and my rabbit was everywhere. The dogs had come in and killed it. I cried my heart out. Now I'm looking after my stepfather's mother's dog, while they go on holiday. His name's Oscar. He pretends to be tough and all that, and as soon as you knock on the door he barks. He's tiny and black and white. I used to have two Rottweilers who were security trained. They even bit my friend once and she had a massive bite mark on her arm.

My dog that I got for my birthday was soppy and everything. My sister could jump over him and he wouldn't do anything. When we came up here, he had cancer and my mother had to put him down.

I don't have a dream for the future. If I could have anything, I'd have a servant and then I wouldn't have to do any cleaning. I'd have the servant do cleaning, cleaning and more cleaning. I don't like cleaning because you get all dirty. If my mother wants to calm down from her day, I do the dishes and make her a cup of tea. Sometimes she has to ask me and sometimes I just do it. The other day I couldn't help her because I had a bad arm and a bad throat. My arm's been like that for ages, but it's okay. I can move my muscles. It's not that bad.

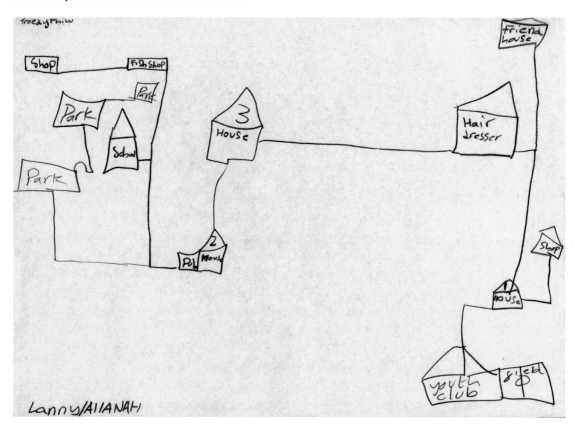

I'd just like to travel the world. First I'd go to Wales to see my friends. I can say a little bit of Welsh, but not really loads. I can count all the way up to twenty. I never want to lose my Welsh accent. In my old school, everybody had the accent. I want to see all the different places in the world. I would have to get a couple of translating books! Obviously, I can speak English and I can speak a little bit of French. Actually I can say *"Bonjour Madame"*. I think it means "Hello Lady". I know there'd be a lot of sea. I wouldn't go to the tropical places, not with all the hurricanes going on! And not America now because Hurricane Ivan is going there. I might go to Africa. I'd take a few old clothes and most probably see all the animals, because I like animals.

LONG
BORN 1993, HONG KONG (VIETNAMESE ORIGIN); ARRIVED IN KENT 2004
RESETTLED WITH FOSTER FAMILY IN KENT

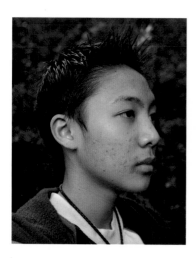 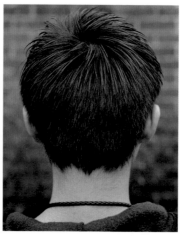

My life was repeated the same everyday. Until, one day, we left Vietnam and I was separated from the person closest to me. That was my father. I was very scared and worried. I thought that a dark and bad life had just begun for me. This chain [necklace] was the only thing he left behind with me. He told me we were going abroad about three or four days, perhaps a week before. He told me not to be scared. We talked normally on the journey.

There was an organisation, people to guide us through. They were okay but distant. They didn't really show any care. At first it took ten days from Vietnam, then another week. About twenty days in total. We came by car, then by plane, then by car. I heard them say that we might have to cross on a ferry. It was very hard. I remember a house when we were in Asia. It was in a jungle. It was very basic, like a hut. It was dirty. I don't like anything dirty. When I got here, I was very tired, so I didn't pay much attention to anything. I didn't know it was England until people told me.

The last time I saw my father was when I got on a lorry three weeks ago. When I got off the lorry, I realized he wasn't there. I'd lost him. Then I got on a car and was transferred to a small room in a flat. I stayed there for two days but still didn't see my father.

Then they put me on a train. When they let me off the train, there was a person who took me to the taxi that brought me here. He gave me money and a piece of paper which I assume had the address of this place. I gave the money to the taxi driver. The journey seemed quite long. When I arrived, at first I didn't see anyone. It was the evening, so it was dark and I was scared. Then I went to a building site and saw people. They took me in. It wasn't 'til the next day that I noticed the people were nice and concerned. I'm going to ask them to find out if there is anyone who has

arrived in England that has a similar name to my father's. Then my father will decide what to do.

When I was in Vietnam, I thought of other countries like America, Laos and Thailand. I also thought of England, because I like English football clubs. When I watched television, I saw Big Ben. I didn't know of anybody who went to England. I only heard that this person has left and that person has come, but I didn't really know who they were.

We lived in Vietnam for seven years. Before, I was in Hong Kong for five years. I don't know why my parents left Vietnam for Hong Kong. Then we returned to Vietnam.

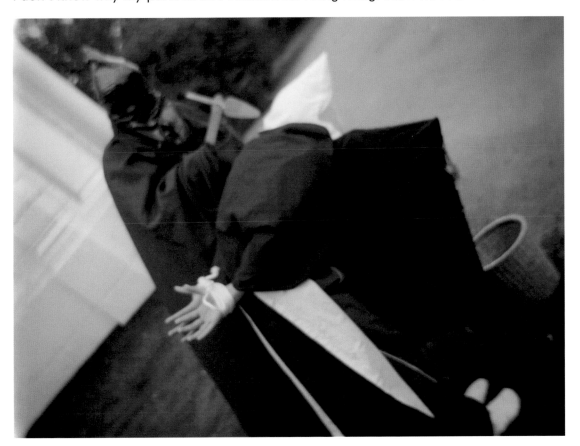

My life in Vietnam was miserable. My mother died when I was very young. I lived with my father. He worked from morning to evening for two meals a day. I went to school in the morning. During my spare time, I wandered around the area where I lived with my bad friends. Then my father came home from work and took me out to eat. We kept moving all the time, moving and moving. Our house was very small and very low. It had a tiled roof, but there was light. There were many different neighbours, but many of them weren't good. They were fighting all day.

I lived in the city. There were only lakes, no sea in Hanoi, but I was happy when it came to summer holidays. I went out to do exercise with my friends in the morning,

then I went swimming in the lakes, then we wandered around. I liked to play football and basketball. I liked anything to do with my friends. When I first came here, I missed them, but not now.

I'm different here. I'm not naughty, like I was in Vietnam. I'm more grown-up. I'm nicer and more mature. I'm still the same in a lot of ways, but I feel happier. I think the English people are nice. They still think of me as a child, but not naughty. They care and include me.

Everything is different, from people, the scenery to everything around me. For example, the houses are very big and high. They are filled with big gardens. In Vietnam there are no gardens. It's very different. Yes, it's beautiful here. It's cleaner. I like the surrounding. It's colder than Vietnam. People are nice and friendly with us. Nice atmosphere. Here they care for me like a second father.

There is discrimination between the rich and the poor in Vietnam. There were a few people who were rich, and they didn't want to mix in with us. It's not like that here. They are helpful here, but in Vietnam you have to have money to get people to help you. It's not good. I don't like people who live just for money. I feel safe here. Life is good. Even better if my father was with me.

I want to go to school, so that I will be able to learn the language better and talk to people. I want to understand what they are saying, so I can feel close to them. In the next few years, I'll go to school, then go to work. If I can study, I will. I'd like to work in an office, a kind of fixed time, routine job. I'd dress very smart and I'd like to do something with a computer. I'm hard working. I have to be. I had a girlfriend when I was in Vietnam, but I've lost her. I don't keep in contact with anyone in Vietnam. Perhaps I'll have a new girlfriend, maybe a better-looking girlfriend. Certainly, I'll get married. I don't want to be a monk. I'd prefer to marry an Oriental wife, but falling in love, whoever, it doesn't matter. I can't say, as long as I will have a wife.

I'll have three or four children. My children will go to school here.

That is enough of my dream, but if dreams ever come true, I want to become a rich person. I'd have everything. I'd buy clothes, a house, a car, a Lamborghini or a Ferrari. One of those cars for leisure, but for my family I would buy a Rolls Royce! Cars are for a rich person. I will also come back here and help people in a similar situation to me.

I have another wish — that when I get old, I could have a farm with animals and plants, with a house on a hill. It would be my hill. It would be bigger than this place, with my family, my children, grandchildren, horses and all the other animals like ducks, hens, fruit trees and vegetables. I'd feel very happy, because the whole family would be together. Now I am here and my father is somewhere else. My grandparents are in Hanoi and others are in Canada. I want a peaceful life. That's all I would like. Perhaps it's only for rich people.

(Translated from the Vietnamese)

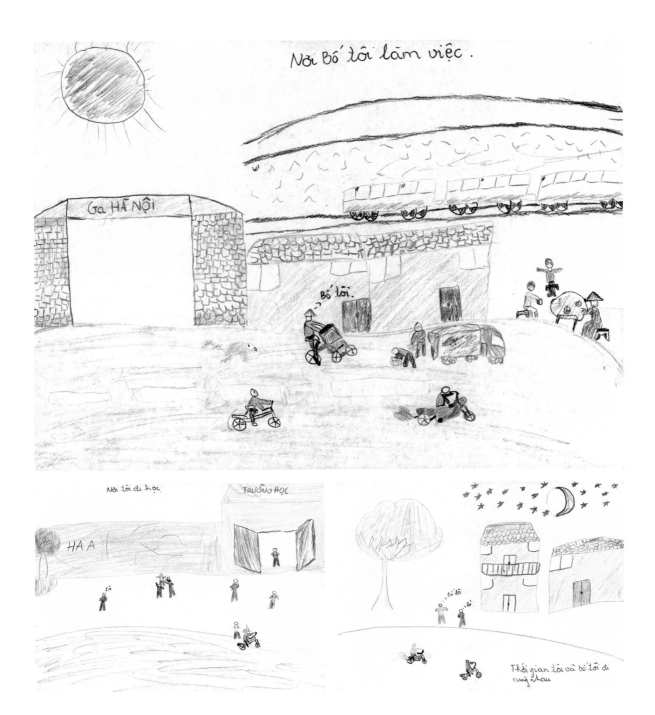

MARIAM
BORN 1995, EGYPT; ARRIVED IN MARGATE 2004
RESETTLED IN YORKSHIRE

The first thing I saw was the road covered with a flock of pigeons. I felt sad and happy at the same time. I felt happy because I had reached England.

Normally people in London do not look at each other in the streets. Everyone cares about their business only. If I ask them about something they will help me. People here spot me because my face is different to European people. I have not talked to anyone as yet to find out what they are thinking. I just know that maybe they notice me because I do not look like them. Some people look at me as normal. Others look at me and I get the feeling they do not like me. And I think maybe that is why they do not approach me. People in Egypt normally approach me and ask me my name to start a conversation. There we speak the same language and we can easily talk to each other.

I brought some clothes and some memories. I brought my necklace and a certificate of distinction from school. I left behind my relatives and my father. I miss my father very much. I talked to him while I was staying with my auntie, but since I have arrived here I have never contacted him again. I always want my relatives, my father or my friends to be with me. Now, I can't find their phone numbers. I did not even have a chance to ring them up before I left.

My family is from Egypt and they have always lived there. Here, I remember the sea because we were living in Alexandria. We had the same view or similar view, but it is cold here. The summer here looks like the winter in Egypt. Imagine the summer. When the sun shines, it's the same. Some of the foods are the same. It's the same in the supermarkets. I like trying new food and I like English food as well.

Home means a family living together and loving each other. Home means a comfortable life and freedom. I don't want strangers to spoil my peaceful, private life. I don't like being ordered by anyone to do this and not that. I want to live on my own

comfortably and be myself in England. I feel satisfied now, but I hope in the future my life will change and I will be a lot happier.

This is a place to wait. I don't know what is going to happen. I'm only thinking about today. This is enough. I want to move to a new place.

Tomorrow it will be a long trip. We have been informed that we will take a journey by bus for one hour from here to another hotel to pick up two other families. Then we'll stay there about two or three hours until ten o'clock. From there we will take another coach to London, and from London we will catch another coach to West Yorkshire. When I reach there I think it will be cold and rainy. I hope it will be a good place, with friendly people and good schools. I hope I'll make lots and lots of new friends.

We will take with us all the things we brought from Egypt. I love my belongings. I will never leave them. They remind me of home. My favourite thing is my father's photo. I like colouring and painting. I like swimming and riding bikes too. I hope to go to a good school and to study hard, so that I can become a paediatrician.

(Translated from the Arabic)

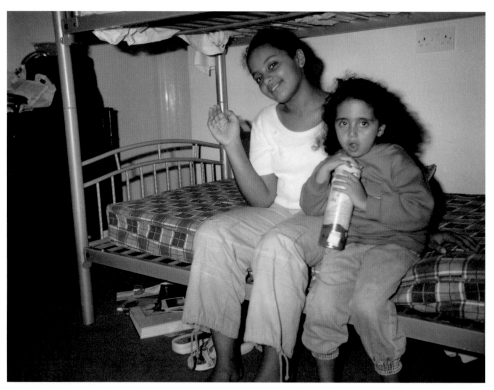

MAX
BORN 1990, MARGATE; RETURNED TO MARGATE 2003
LIVES IN MARGATE

The map of my life would be very crossed over, because I've been in so many places, so many times. It's kind of like a routine. My first home was up in Palm Bay, but that was when my mum and dad were together. Then they split up and my dad got one in Whitstable and my mum got one in Garlinge. In the next house, my mum was talking to her friend on the phone and she put some chips in the chip fryer. She fell asleep on the phone and the chips got out of hand. I was in bed, but my sister woke up and saved the day. We had to get out then. The bloke who owned it said, "You can either pay for all the damage or move out". So we moved out.

Then we got this house in Millmead. It wasn't a very nice place to be around. There were loads of smoking teenagers, although that's where I learned to ride a bike. Then we moved back down to Garlinge, to a house on Kingston Avenue. Then we moved out of that one. I've had so many houses, I can't think what road the next one was on now. Then we moved out of that one and we've been in the new place now for about two months.

I think home is just a place where I can put my hat, really, and get food, go to sleep and then chip out the next morning. Sometimes we move because of the neighbourhood. The first night I stay in a new house, I can't really sleep. It's a new atmosphere. I like this house a lot more than the other ones. It's bigger. All the other houses we've had have usually been either one storey, like Palm Bay, or two storeys.

This one has three. I feel pretty safe.

It's always the same: pack, find a place to put it all, find a new house, go over there and get in as soon as possible. I pack up my own stuff. Usually, my dad brings his van down or they rent one. There is one thing I always take with me, my *X-Men* comics, because I collect them. I've got hundreds at my dad's place and about another hundred at my mum's place.

This time we were in a rush. My room's not even decorated yet. It still has loads of the old wallpaper on in it. We were staying at my grandma's house, but they were selling it off quickly so they can go on a world tour.

Each time we move I lose stuff. I used to have loads and loads of Action Men. At Swain Road, I lobbed them all at the wall and broke them. I had a Sega Megadrive once, but when I got my first Playstation, I gave it to my cousins. Then I got a PS2 and I gave my Playstation to my sister. That one got nicked and I got another the next year. Then last year, I got a GameCube and an Xbox.

I think it was when I was three or four that my mum and dad split up. My older brother Zack lives with his mum. I only saw him for the first time about four months ago. We've been in contact since then. My dad had loads of pictures of him when he was a baby, but his mum was afraid that if Zack got in contact with my dad, he would whisk him away and take him to another country, so she wouldn't let him see him.

My younger sister, Bryony, she goes to this school and she's in year eight. My other little sister, Millie, she goes to Garlinge. Then there's my little brother George, who I usually wrestle with.

Bryony and me are my dad's children and there's another father for Millie and George. He split up with my mum as well, ages ago. They had a massive argument and just moved apart really. He wasn't really that nice. He was always swearing around the house and stuff. He even broke our fridge once. He punched it. He was stressed. He doesn't pick Millie and George up on a regular basis, although he did give them a couple of good presents and lots of money at Christmas, to try to make up for it.

I used to not like it that my parents split up. I didn't like not being able to see my dad all the time, but now I think it's cool. Every weekend I'd go to my dad's, but now it's every weekend once a fortnight. He comes and picks us up from the house. It is really fun. Usually we'll go to the cinema or I'll go down to Canterbury.

I get in trouble a bit at school, but not as much as some of the other people do. My dad says, "If anyone gives you trouble, just smack 'em one in the nose". Good philosophy. There are quite a lot of fights down here. Usually, when you just get stuck in, it's quite fun. Fists flying everywhere.

I'm kind of a jackass, really. I like jumping off trees and falling out of them, doing anything dangerous. I guess I'm quite intelligent, because I usually do get high grades. In general, I'm quite funny. Loads of people know me and loads of people like me.

Usually, all the skaters I hang around with think I'm one of the toughest opponents they got up. There are Skaters, and then there are people that don't skate,

called Grungers. Skaters usually hang around good places they can skate. Then there are people that dress like Chavs but aren't. They're called Townies. Chavs just hang around arcades and seafronts, and Townies are always uptown. It's just the whole attitude really and who you hang out with. Chavs, they always dress in Nike and McKenzie.

You can move from one group to another, but to be a Skater, you have to skate. It's kind of how racism used to be. Like Chavs hate Skaters and Skaters hate Chavs. It's all conflict, really. Usually we just mouth off at each other, but if it does get into a fight, then we just fight. I'm more like a Grunger, because I don't really skate.

Margate and Whitstable are my homes. I've been in the high school in both and I've got relatives at both ends. When you move somewhere you just try and fit in. You all just become the same, really. It's pretty easy to fit into Margate as long as you can speak decent English. If you can't, sometimes there's problems with communication and that can lead to a fight. Here there are colleges and places you can go just to learn English. The council sorts all that stuff out. But when I'm walking around, I hear people being racist and stuff. They say, "Go back to your country!" and stuff like that. I just think they're a bunch of arseholes.

 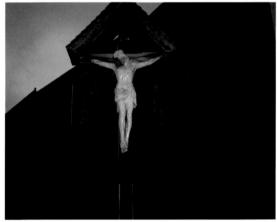

In my old school, this bloke called Sam said, "I've got this little red button on my remote that can call the Kosovans just like that. They come and beat anyone up". I was like, "What are you on about?" It's obviously not true, but I think they are a bunch of gangsters that gave themselves the name "Kosovans."

Refugees don't really have a choice about moving, since there's a war going on with Saddam Hussein. There's room for them to stay here, so I guess we kind of take care of them. A lot of them work at KFC. There's actually no person who can speak proper English there.

My dad's a builder and my mum collects money for TV licenses and stuff. She might be taking on a contract to deliver *Bliss* magazine. I'm going to have to get a job here. I'll probably move out in a year or two once I've got enough money to back me up for a while. Then I'll get a better job. It's quite hard since there's so many people in Margate. There are not very many jobs on offer. All the pay's gone down.

Disneyland Paris

Norfolk Road 13

Surrey Road 12 – 13

Grandad Knysna
8 – 9
mummers 7 – 9
Granny Worcester St.
Granny Mc tuning
7 – 7
L – 5

Margate

Maggie

Granny

Pam boy 1st home
1 – 3 yrs

Car

Car

Car

Car

Car

Car

Whitstable
Dads house

OMAR
BORN 1989, IRAQ; ARRIVED IN KENT 2004
RESETTLED IN KENT

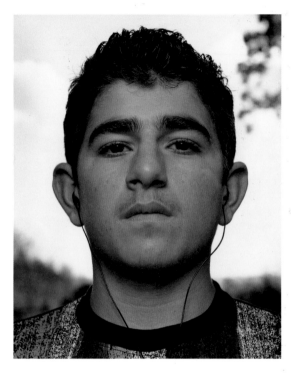 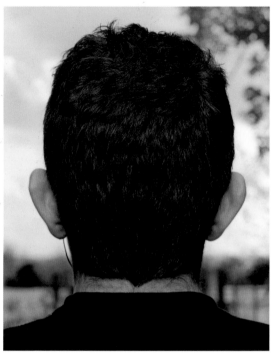

Sulemani, where I was living in Iraq, is an unsafe town because of explosions. Kurdistan is a nice place, but I had no family left there, except a sister. That's why I thought of leaving for Europe to have a better life. Actually I had decided to leave the country two years before, I was just waiting to be a bit older. I thought about Britain because it offers asylum and it is a nice country. It has no problems.

We were living in a deserted area in a remote part of the country near two other houses. Suddenly, my father, together with three other people, was killed by an exploding mine. After the death of my father, my mother remarried and we moved in with my uncle. We stayed there for about six months. But my uncle wasn't happy about our being there. So, with my sister, I moved to Sulemani. We rented a house there and I started to work, because otherwise we could not survive.

I did all sorts of work as a labourer, working in a mechanic's shop. Before I became apprenticed, I had to go to a certain place and wait there with other people to be picked up as a labourer. I wasn't happy about it, but it was better than depending on others. We had a comfortable house of our own, but it wasn't ours. We were paying five hundred Iraqi dinar rent [about GBP 50]. I could not afford food every day, only two meals every five days. Other nights, I just went to bed early. To be living with my sister made me happy. She was only fourteen years old and she was studying.

I had been deprived of an education, so I wanted her to have a chance and decided that she should go to college.

When I was younger, I had no worries. My sister and I played games with other children. I had no fear. But when I grew up, I started to think of life. There were problems because of the fall of Iraq. Sulemani got worse. We had a bad life. So for four years, I saved money. What I saved was still not enough for my journey, so I borrowed to complete the payment. I found the agent myself, then went to his office and spoke to him personally. Agents are usually liars and give false promises. This agent said the journey would be by car and other vehicles, but we ended up walking for thirty to forty hours. He promised that I would be fed well during the journey, but sometimes I did not eat for a whole day. He said that the journey would be very comfortable, but it was very hard. Sometimes I even had to hide in a box under the vehicle, under the lorry for two days, while the lorry was moving. The place where I was hidden was made for the spare tyre, not for a human being. Sometimes they squeezed five people in there. It took seven or eight days to get from Turkey to the U.K. It was bad.

My sister travelled with me to Turkey. The police were after us illegal immigrants. We were separated and the human traffickers didn't care that we'd been split up. I couldn't find her until I came to the U.K. I tried hard. Finally, I was able to find out that she went back to Kurdistan and I was able to contact her. She's living at my uncle's house. I'm always thinking of her. I left her alone and I don't feel good about it. We'd both like to be here, together.

The moment I arrived at Dover it was nice. It even smelled nice. I remember seeing gardens and shops and the town. I had an idea about Britain, because I was watching satellite TV at home. The same thing I had been imagining, the market, appeared. I was happy to be here, except that I was always thinking of my sister and that upset me. I couldn't bring anything with me. Later she sent me a pair of shoes and a few photos.

I prefer everything in this country. It's neat and clean, although I know there are some problems in some places. I heard about problems in Birmingham because of the numbers of refugees there. It's not just here, it's everywhere in the world. When you make problems, people don't like you. But when you don't make problems, people will be good to you. For example, if I go to the market, I find that if I look at certain people they might take it badly. Sometimes they look at me in a way that I feel might bring me problems. I worry about it, but I think it's better if I speak to them. So I believe that if you love peace and happiness, you can meet very good people.

Because I haven't been here long, I haven't really mixed with the people of this country or seen many other places. I speak more easily about the difference between Sulemani and this country than the similarities. Kurdistan has a Sunni Muslim religion whereas Britain is Christian. Here there is a lot of freedom to go out with girls. It's easy and normal. This attitude doesn't exist in Kurdistan. Sometime you're even

forbidden to look at a girl. I had a girlfriend but our friendship was secret. I haven't had the opportunity to have a girlfriend in this country.

When I first arrived, the key worker asked me what I would like. I said I would like to have a bicycle to ride around. One day the staff told me that the bicycle had arrived, but after the first day, a Moroccan boy hid it. When I asked him and an Albanian boy for it, they beat me up with a piece of wood. I wasn't afraid of them, but I wasn't looking for problems either. When the Albanian boys were here it was very difficult. They behave as they do in their own countries, imposing themselves and using force with the other boys. It wasn't just my opinion; the Afghani boys said the same thing. All the troublesome boys have already left, except one Iranian boy. It is better now.

There are good people and bad people everywhere. There are no Iraqis in this centre, but when English people are killed in Iraq, we receive threatening phone calls from other English people. One evening they came to the centre and damaged one of the staff cars. They probably hate foreigners, refugees and asylum seekers, without reason. Why don't they blame the government for how they feel?

I feel happy here, but I'm always thinking of being in a peaceful place where there are no problems. I feel like a guest in this country, so I would be ashamed to take part in making trouble. Now I work in a supermarket one or two days per week, for which I don't get paid. There are things I don't understand. I don't mix with local people much and I feel shy when they talk to me. I have no complaints about the centre where I'm living. I feel happy, although I'm a bit hungry at the moment because I'm fasting, and I need some cigarettes to smoke. I have no idea what will happen to me. I'm not even sure if I will still be here this afternoon or suddenly be transferred away.

I think about having a house where I could be on my own. I expect that I will be offered accommodation and granted some official papers to stay here. I'm afraid of being deported to Kurdistan if my asylum application is refused.

I am a human, as any human, no more.

(Translated from the Kurdish)

ناو دەستم رازاوە کراوە بە رەسم

My palm decorated by pictures

RABBIE
BORN 1993, DEMOCRATIC REPUBLIC OF CONGO; ARRIVED IN MARGATE 2004
CURRENT WHEREABOUTS UNKNOWN

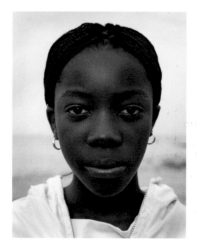

 I am from Congo, from Kinshasa. I came by plane. It was my first time on a
plane and it was good. At the airport, I saw the policemen with the customers. People
were showing their passports and asking questions before we passed through
immigration. They didn't ask me anything. We passed the bags through the machine.
We brought some clothes – not toys – trainers, medicine and then the telephone. We
left my house, aunt and uncle and the dogs behind.
 I like studying, watching telly, playing basketball, going to the cinema or playing
Barbies. Just enjoying ourselves. I liked *Spiderman 1,* kid's films and films that show
us people at school. My favourite film star is Tobey Maguire. I saw *Spiderman 2* in
Kinshasa.
 We haven't done anything we like here. We're too trapped where we're staying.
We eat things we don't like, that we aren't used to eating. You can't shout and play
because there are neighbours. And then, the space is too small. We don't study. I like
going to school. Our school in Kinshasa was good. There was our teacher, my friends.
We used to play at break. It was good.
 My house was a typical African house. It wasn't too big. It was a rectangle. It
had a veranda, two living rooms – one for grown-ups, one for kids – and a big plot of
land. And opposite, there were flowers.
 It wasn't good before we left. There's war. The day I went for the TNAFE exams,
there were the people who were against the president and the vice-president. They
came into our school and set off gas so that the pupils would leave. They took sticks,
and started to hit everyone who was passing by. They were saying that my sister was
Rwandan and that they don't want her or my dad. They climbed up onto our car, but
the sticks didn't work because we were in the car. One window was broken and the

tyre had holes in it. We gave a bit of money and they let us pass and we went as far as the house.

It was in all the districts of Kinshasa. People were like that because they were against the president. For at least three days we didn't go to school because of that. I was sad and insecure. They also came to the house to beat us. It was like that in almost all the houses. They were looting. In other houses they killed the parents. When they come into a house, they want to hassle the father, to kill the dad and a child or just the dad. They cut off the head of the dad of a friend of my sister. They came and they asked where is our dad. They were even looking for our mum. They said if we didn't show them our dad they'd shoot all of us. But because our dad was dressed in shorts, like everyone else, they didn't know it was him.

I thought England would be very, very beautiful, a sort of paradise, and there would be safety. They say that in European countries, people live in peace and safety. There is a very, very, very big difference from Kinshasa. There it is too hot. But here sometimes it's too cold, sometimes, hot, sometimes nice. I've seen snow on the telly. I'd like it to snow. I'd make a snowman. Here, the people are clean. There aren't too many cheggies [street people]. There it's dirty. People piss and pooh in the street.

At home there aren't even buses. There are Combis, little cars like buses, but they're already damaged. They're yellow, red and black with lots of smoke. It gives me a headache. There aren't enough roads. There's only one main road, the Boulevard du Trente Juin. On little roads, it's impossible for two cars to pass each other. If you see another car coming, you have to pull over to the side. People fight everyday in Kinshasa because of cars. They insult each other. "You knew it was me that was here first. You should let me pass!" There aren't even traffic lights. You will see wardens making traffic signals. "You! Pass by!", and all that.

 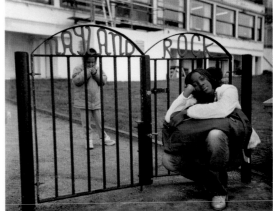

We don't want to lose our culture. Where we're staying, the food is too spicy but with no salt. It's monotonous. I would love to eat *fufu, pondu* and fish. *Fufu* is a kind of semolina. Pondu is like a salad (cassava leaves). In Lingala, fish is *piodie.* In Kinshasa,

you won't find a pierced person who wears strange things, like a mini-skirt. People don't walk around in small shorts. You can wear trousers like me, but you can't wear small shorts. We can't let our stomachs show. It's forbidden to have boyfriends. It's not good at all. We want to keep to that. We will behave how our mother wants. We won't become like the children here, because the children from here smoke and they don't dress at all correctly.

We haven't had the time to go out yet, but I feel safe because in Congo you can't spend two or three days without hearing bullets. Each night, you'll hear people running, shouting "Moibee!" They're following a robber. There are robbers who come into the house to steal, really to steal. In Congo there are also police who steal themselves, so you can't do anything, because where are you going to go to accuse them? In Congo I was afraid of the street people, of insecurity and rotten cars. There are drivers that take drugs before driving. They get a frazzled head. Here, there are dogs everywhere. I'm afraid of them.

We were feeling happy. Happiness! But also a bit of sadness, because we knew my father had to cross to the other side with my two older brothers to take the plane towards South Africa. We didn't have enough money to come here together. My parents told us to get ready, that we were going to move. But when? At what moment? No. Only when we went to have our hair plaited, they told us, "We're having your hair plaited because we've got to travel".

It was morning, not too early, but still morning. We took the plane and made a stop in Kenya. Then we came to London and we went to report to the Home Office. The Home Office made us wait until the evening, very late, around eleven at night. Then they took us and dropped us off somewhere, somewhere like here. We didn't eat all day. We were sitting on chairs while my mother was being interviewed. I was tired and a bit worried. My sister wasn't worried because she was sleeping.

In Congo, there are certain children whose parents aren't well off. They're a bit poor. When they see a white person, they scream, "Mondele! Mondele!" They see a white person almost like an angel. There are people here who are happy to see us and there are people who aren't. There are racists, like the grandad who threw a stick at us, telling us to go back to our country.

We discovered a church here. When we went there, there were happy people. They welcomed us. They gave us books to sing from, but we didn't know the words. There was the priest, who was happy to see us. He said to us that he was very, very happy, that next Sunday we could come back. There are other people who say hi to us when they see us going down the road.

I hope racists will change.

(Translated from the French)

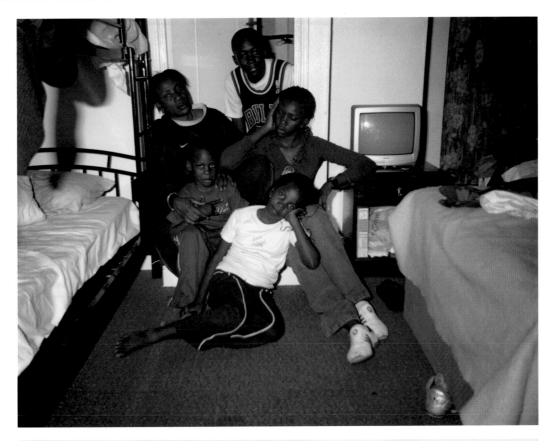

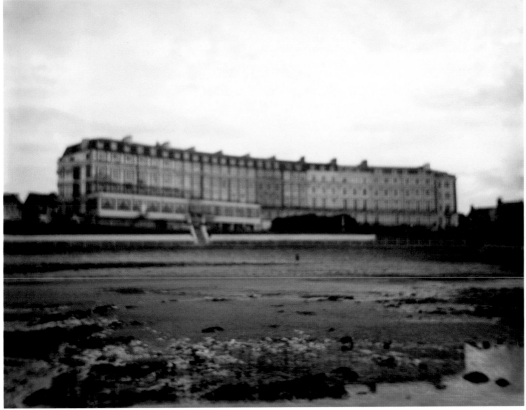

REECE
BORN 1991, IN LONDON; ARRIVED IN MARGATE 2004
LIVES IN MARGATE

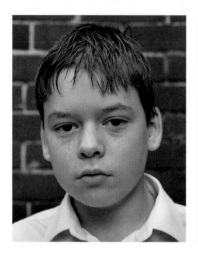 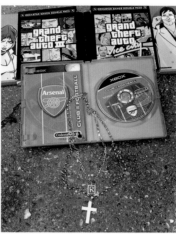

We've moved four times — from London, to Margate, then Margate to Ramsgate, then Ramsgate to Margate again. The one thing I took with me everywhere is a speaker that stands about a metre and a half high. My brother sprayed it metallic blue and silver, so it looks quite good. My mum's brother made it and it's been in our family for ages. I lost a couple of photos of my dad holding me when I was born, when I moved from Ramsgate to here. I was disappointed because I've had them for ages. My mum gave them to me.

I'm living with my mum, my stepdad, my uncle is staying with us at the moment, and my brother and sister. My big brother's got his own house and my little sister is with my dad. We've been in Margate nearly a year. We want to move because the house we live in now is rubbish. We're not bothering to decorate it, because it's falling down.

Moving hasn't changed my life. I would say I'm lucky really compared to what some people have. When I start to make friends though, we have to move. Sometimes I dream about my friends down here. I only have a couple. I have a dream that they're going to be murdered. And then I wake up.

I remember some bits of the first house we had in Margate. I can remember the front room. I was eating my dinner once and someone threw a glass bottle through our window and smashed it. It was a woman and she was pushing a pram. She ran away. Must've been one of my mum's friends.

My family think I'm annoying. I always annoy people when I'm bored. I bang around everywhere and go upstairs, walking, stamping my feet because I'm bored. I don't know why we moved here. When I had an argument with my dad, I punched a hole in the wall.

My mum's a housewife and a cleaner. My stepdad's got a good job. He works

with my big brother sometimes, putting up plaster boards and plastering and tacking and all that. Sometimes he can be moody. Sometimes he's alright. I'm close to my brothers and sisters. My big brother lives around the corner from me. I want my sister to move out, so I can be the man of the house. She always bosses me around.

My parents split up just after I was born. I've never lived with my dad. I couldn't get into school anywhere because we were all over the place at the beginning of the year. No one would give me a place. It was boring at home and I had nothing to do. I was a bit disappointed, because I really wanted to get into a school. I used to like school, but don't really like it that much any more. It's hard work.

I remember the first house we had in Margate. We lived there for three years. Then we moved to Ramsgate for about three years again. I wanted to stay there but we got evicted from our house. I wasn't really bothered about what was going on, just angry we were evicted. It made me angry. When we moved back to Margate it was weird. It brought back memories — where I used to go, what I used to do and all the people I used to see. Now I'm allowed anywhere around Margate. My favorite place is down the seafront on Friday nights because you see all the women in miniskirts. I like to go to the arcades and gamble. I can only play two machines apart from all the 2p ones. When I play, I always win. One's *The Italian Job* and the other's *Happy Street.* They're money machines. The most I've ever won is fifteen pounds. I was happy! I put it all back in the game. I went in there with one pound and fifty pence once. I just kept winning and winning. If I kept all that money in one go, I would have won fifty pounds. It felt alright, but when I lose, I don't like gambling. I don't do it as much as I used to. Now, once a week or once a month.

There are people here that speak to me in a different language. People come from China and all that. I don't understand them and I'm like, "What the hell?" It's normal. People don't understand me all the time either, especially when I talk fast.

The people in Margate are selfish and ignorant. When we were living in London, it was a lot dirtier and a lot more druggies. But there are more druggies here now. I think they're disgusting. I don't go near them. I might catch AIDS. I've seen someone put needles in before and it scared me. I get scared of people who are drunk and come say, "Come on then!" and start giving it to you.

A good day is when I've had a lot of fun, going out and doing things that I don't usually do, like going down Revolution on my BMX and going in the arcades. Sometimes when my friends knock for me, I can be boring and not go out. Sometimes I go knock for them, but they won't come out. So it's fair, really. When we go out, we always go to the same places. I like just hanging around. At home I play computer Xbox. I play *Grand Theft Auto:* Vice City. You get to rob cars, shoot people in the head, shoot their legs off and rob things. It's quite cool. You can't do the same thing in life.

I don't really like Chavs even though I dress like one myself. Chavs think they're all hard, but if they want a fight, I'll give them a fight. I'm a normal person, not a grunger. People say I'm a gangsta, but I don't do any of that. People say, "Why do

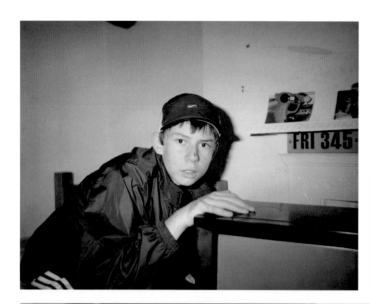

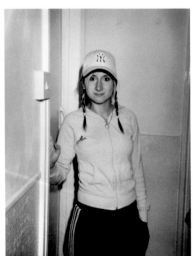

you dress like that? You aren't even one of them".

People get drunk a lot on weekends in Margate. I'm always out on the weekends down where the nightclubs are. I hang around there and just see lots of people out their face walking down the street. They can't walk in a straight line. I think it's funny. Sometimes I have a laugh. At New Year, I got drunk and I had a really bad laugh. I went out with my brother, and got some beers. We came back. I downed about two litres of cider and Strongbow and Fosters, Stella, Morgan's Spice. I took shots of it and I was out of my face. I started telling everyone, "I love you". I didn't know what I was doing. That was the first time I got really drunk. I threw up all the next day.

I want a better life than what I have. I see myself getting my own house in the future and two kids. And a wife, although that's the one thing I don't want because they really get on my nerves, wives. They take your money. They're just no fun. I want to be an electrician and to have a decent job. I just take after my dad…

REZA
BORN 1991, AFGHANISTAN; ARRIVED IN KENT 2004
RESETTLED IN KENT

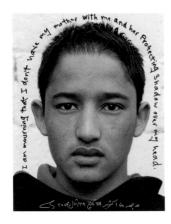 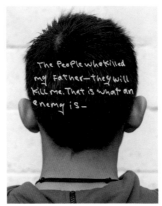

I was born in Afghanistan. Because of the problems in Afghanistan, I could not continue my life there. I had to leave and, with a lot of difficulty, go to a country where human rights are respected. I really don't want to talk about it. There was chaos in Afghanistan. I left because my life was in danger, because the situation in Afghanistan was not safe. There was war. I wanted to get away from all the pain I had suffered, to live in a free country.

My father was working for the army and, because of that, he had been killed. The people who killed my father will kill me. That's what an enemy is. The people there are from different tribes. To me it means nothing, but my uncle explained to me that another tribe killed my father. After that, my uncle and aunt decided to send me to Iran. They sent me and I had no choice.

My uncle told me, "If you leave Afghanistan and go to a safe country, you won't be killed". I don't know if there was war with America then. Our enemy came from our own tribes. They had seen us and knew us. My uncle told me, "I'm going to get some money for your trip, so that you can leave". Then he escaped from Afghanistan and went to Iran, but my aunt stayed behind. She left me for two or three nights with her friends and then told me that she'd be sending me to Iran with someone.

One night they came for me. I travelled by car. Then it was four or five hours' walk until we arrived in Iran.

When I got there, my uncle gave me to an Iranian family, with whom I stayed for two and a half years. I was with an old couple and I helped them with the housework. I didn't have a proper job. They asked me for some help and I helped them. We spoke in Farsi. I learned it. It wasn't hard.

It was difficult there because the police could get you. If you went out, they would stop you and give you a hard time. According to their law, you can't go outside. The Iranian government never gave anyone papers or a visa. If they caught you, they

would send you back to Afghanistan or put you in jail for one hundred days. I felt really bad.

 Nothing is left. Our house was a mud house. It was really risky and could have collapsed any day. If it rained, we thought we might die under this house. I had friends, but because we were moving to different places, I didn't have so many. I've got one brother. He's younger than me. We'd play volleyball sometimes. I was better at it, but I let him win sometimes so he would become brave. But my auntie told me that when I left for Iran, they were going to send my brother to Tajikistan or Pakistan.

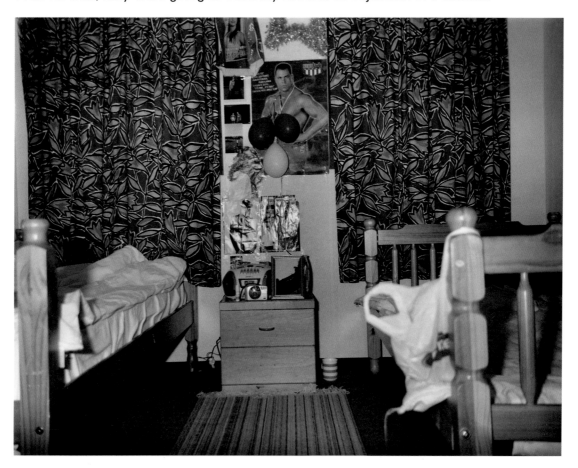

 I don't have any contact with my family or friends there. I don't have a family, because my father has been killed and my mother's missing. My father was killed outdoors, somewhere in Kabul. And as for my mum, she fled one day while I was at school because there was fighting. When my brother returned, he told me that my mother had gone missing. I am in mourning, because I don't have my mother with me and her protecting shadow over my head. If the whole world forgave me for a mistake, it wouldn't be as much as a tiny amount of forgiveness from my mother.

 When I left Iran, my uncle told me, "You'll be going to a country that is much safer, where human rights are respected". My uncle also wanted to leave for an

Arabian country. He told me, "I'll send you one way and I'm going another because your father's enemies know that I have taken you up, therefore they will try to kill me. I will hand you over to an agent. You have to listen to what the agent tells you. If you don't listen, he won't take you anywhere". I didn't know this man and I didn't know which country he would take me to. For two and a half months, I faced a lot of difficulties. I never laughed once. I travelled to one country with one group, and then with another group to another country. I was never aware where I would be sent. I saw a lot of lorries on the journey. There were lots of problems. I stayed overnight in forests. We were told that police would arrest us if we left the forest.

When I was going from Iran to Turkey, we walked for a whole night. Then we would go to a house and the agent would tell us to sleep there. The next night we would walk again. I think it took about thirty hours. For two days and two nights, I had no food or water. This was a tough experience. I was very afraid of the police. The people who were travelling with me knew that we were in Turkey, but I didn't know where it was, nor did I care. I heard that if the Turkish police catch you crossing the border illegally, they would shoot you. Sometimes I'd ask the agent where we were and when we would arrive in the country we are going to. He would tell us to be patient. "We will arrive there", he'd say. "Don't you want to go to a safe country? If you do, then you must wait."

On the border, the police opened the lorry. They had yellow clothes. That was completely different for me. I had never seen these kinds of people before. I was scared. They picked us up and questioned us. I told them the whole truth and that my life was in danger. There was another old man. He brought us here. When we arrived, we changed our clothes and we had lunch. And it was good.

When I arrived, I was very happy. I started my life from the beginning. I didn't know, but my countrymen told me that this was a very good country. It's a start and I'm happy.

I never thought about what I wanted to be when I got older. In Afghanistan, there was college for two or three months and then there wasn't any for two or three months. I used to play with the boys of my age. I like playing football a little bit and volley ball. I understand volley ball. I learnt to play pool in Afghanistan. It's good to pass your time here, because we don't go to many different places. When I first came they used to take us out, playing football once a week and so on. We used to go swimming a lot, we went to the seaside and once we visited London.

London is good. The more I go, the more I like it. I like everything about it. I'd like to stay there longer. I have a friend in London. I know him from Iran. We shared a journey for some time. That part of my journey was much better. The other people with me were older and he's not that much older. He was helping me. He would advise me to be safe when getting into the lorry, and to do this and that. It was a help. After that, we were separated. I feel good, happy, when I see him. He's got a house in London. We catch a bus, because he knows London. We go to different places, like going to play football.

I don't know what will happen. I mentioned that I wanted to live with my friend, but they told me that I was too young and had to stay with a family. I am a bit scared because lots of boys are living with families and complaining. A boy who was with me in Turkey ran away. The boys get bored because they might be in an elderly couple's home and there is nothing to do. But my social worker tells me that the families are good.

I'm happy with my friends here. I didn't think I would have any. I don't want to leave them or separate from them. Especially this guy. We were together on our journey from France. But we are going to be separated, which will upset me. The first time I saw him, we were in the same lorry and he was in one corner sleeping. I was on the other side of the lorry. When we got off the lorry at Dover, they pronounced us to be under age.

I had no religious or cultural information about England and, at first, it was difficult for me. Here, the food is different to ours. They cook food that we don't eat. I don't like British food. Instead, we eat eggs with bread, but apart from that I have no other problems. I want to stay here. I'm trying to live the way people live here.

I am disgusted with Afghanistan and I think if they send me back there that would be very scary for me. I had a hard time in Afghanistan, a really hard time. I'm scared that if I go back I will be killed, or something will happen to me. At first I used to be scared all the time. On my journey here, the people I travelled with used to tell me, "You might go to a country that deports you back to Afghanistan". But I arrived here and now it's okay, I just want to say that everybody feels pain. I don't want to mention Afghanistan. I just want to stay here.

I like this country. I had no idea which other country we'd go to, a country that would have human rights, which would mean a safer life for me. That's it. The best thing about this country is freedom. Another thing I like about the U.K. is that they respect me as an Afghan and that the rights of the underaged are recognized. In Afghanistan, there is no difference between a five year old and a fifty-year-old man. When you're a child, you are fed so that you grow up quickly. They don't care about how you grow up, what you want or don't want. I am the kind of person that, if somebody respects me, I will respect him or her. I never lie. I love freedom and that's it.

I want to study to be a professional, forget the past and continue my new life. The pen says, "I'm the king of the world. Whoever holds the pen will be given power by me". I will see what happens. I want a normal life. I expect to be a professional. I just want to work day and night to provide for my food. This feels like a home because I live here. I feel safe because nothing has happened so far. I belong here because I live here. Anytime someone lives somewhere, that's the place he should belong to.

(Translated from the Dari)

زانگ ای

کوتا

مشذکاستم

دین دنیای دوروزه چرا مزودی کودی

سلیان مرشی اگر سید سدی کرد

سلیان یک لحظه بود در دنیا قبل که قدرت دس وکاهان ماخدا ونرد دردست دش داده بد

بالاخه از بین دنیا حطرت حست دنیای سعرماس من مورع کردند

دوش

SHAKEEB
BORN 1989, SUDAN; ARRIVED IN KENT 2004
DEPORTED TO ITALY; CURRENT WHEREABOUTS UNKNOWN

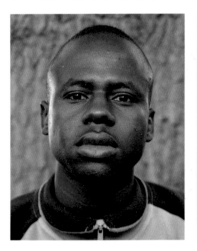

I come from the Sudan. Life is okay. There's the good and the hard. The good things are that you live and lead a normal life; that you're back home with your mother and father, your family, your sisters and brothers; that you eat and drink well. These are the good things. The hard things are wars and mass killing.

I'm a shepherd. I was working in a nearby area outside the village, tending a herd of sheep. I had witnessed that the village was burnt, and many people got killed with no survivors. My whole family was there, my mother, my father, my uncles, my sisters and my brothers. But I was not sure whether they escaped or were killed. Inevitably I had to flee the country.

I don't know for sure the reason my village was burned. Maybe it's for genuine reasons or for silly reasons. There's a new political movement in Darfur. The guerrillas of this movement were fighting against the government forces in the region. The guerrillas had training camps close to our village. The government was aware that our village had nothing to do with this political movement, but it kept charging our village with siding with the movement and supporting its guerrillas. The government is absolutely wrong in doing so.

Perhaps some of the young men in the village were involved in the conflict. But, suppose that was the case, how come the government would burn the village down as a mass punishment? Maybe those gunmen are leading this resistance in order to bring notice to their request for their rights, and probably this is the only way to have their voices heard. But the burning of the village caused the demolition of peoples' houses. So people became homeless. Many of them were forced into compulsory exile. Small children were massacred and the elderly people were pressurized to abandon their homes.

I was trapped in the village for a while. I couldn't stay there and I couldn't leave either. I felt scared and I thought I'd be the next to die. It was too risky for me to stay in the village. I decided to escape. I was panicky. I didn't know what to do or where to go. When the guy whose herd I used to tend saw me frightened, he reassured me and gave me advice about leaving, how to escape the country. He accompanied me down to the harbour and he introduced me to some agents there.

Generally, I was feeling okay. My only concern was that had the Sudanese government caught me, they would have killed me. All I can remember is that I boarded a ship and it put out to sea. But I do not remember exactly how the journey went on. I was shattered. I was hiding from the people in the ship. I was worried that if a member of the crew of the ship had spotted me, they would have returned me back home. There was only one person, the agent, who was aware of my existence. He provided me with food, water and everything I needed so that I could comfortably stay there without people noticing me. He warned me that at certain hours of the day I ought not to walk out of my hiding place, until I reached my destination.

On the last day of the journey, just a few hours prior to our arrival, the ship docked. The agent came to me and guided me till I disembarked the ship. Then, he instructed me to go underneath the lorry, which would board the ferry. The ferry journey, he said, would take two to three hours. When the ferry arrived at its destination, the lorry would drive out of the ferry. Then I should get off the lorry at the first stop and walk. And so I did.

The ferry was carrying lots of vehicles. I discreetly walked on the dock and I could see some lorries driving through and boarding the ferry. I sneaked on and I hid myself underneath a lorry. When the lorries began to drive out from the ferry and while they were queuing for customs clearance, the customs' staff, as they were going through the lorries, spotted me hiding under one of the lorries. They brought me out and rang up the police. Officers came around and interrogated me. Later on, they brought me to safety. It was such a wonderful, relieving moment. I was really happy.

The first thing I saw was a TV set. I'd seen a TV, but in Sudan, I only had a radio. I didn't realize I was in Britain until I arrived at Dover Harbour and the police arrested me. I didn't really know anything about Britain, but I had heard of London from a Sudanese newscaster called Ayyoub Siddeeq. I'd listen to the radio at ten pm in my house with my father, my brothers, my mother. Everybody catches up with the news. I particularly like catching up with the news. This is what we like to listen to. I didn't know what London would look like.

The English have water in their rooms, but in the Sudan you have to walk probably three or four hours to get water. Also we don't have cars. We have donkeys, camels, mules. We don't have solid buildings. Our housing is made of wood and hay. Every year, fire burns some of those houses. They are vulnerable. There's no good education there. These are some of the differences. Of course for me being with my

family in my country is different to being here alone. I cannot see any aspects of similarity between the two countries.

In England you have no killing, but in the Sudan killing exists. It scared me to see the safety of my family destroyed and my village burnt down, leaving no future for us. I'm still worried about the situation there. I brought just my clothes with me. I left lots of things – mattresses, sheets, a radio, clothing, so many things. I don't want to lose my family. I know one person here from the Sudan. He is one of my relatives. I phoned him. I told him where I was and he asked me about my stay here. We talked about the violence in my village and he found that he was aware of it well before I arrived in Britain. And he phones me from time to time. That's enough.

After arriving in the U.K., I felt much better. But, of course, before that I felt really anxious and scared. I didn't know what it would be like in this country. I was expecting to be in a poorer condition. I never dreamed of something better. My worry was that in the new country I might find the same acts of killing like the Sudan. Or maybe the people there would say, "Oh! You are Sudanese, and you have to go back to your country". And then I would face death there.

Asylum seekers may face some problems in the process of obtaining official papers to stay legally in the country. One of those problems is having their asylum application declined, and eventually being deported to their country of origin. If I

went back, they might take me to court and execute me. I hope to be granted asylum so I can stay in this country. Anything else can be handled. It is hard to predict the future. You can already recollect what happened to you in the past. But it is difficult to predict the future. My dream is to live in peace and not get killed.

Britain is a good and nice country. The people I've seen so far are good. I expect the others will be the same. What I like best is the education. The level of education in the Sudan is not that good. If you don't have the money, you are deprived of education. Here all the people are alike. The rich and poor are equal. This is what makes education in this country better. It's accessible.

I wish I could be rich and have big wealth. With this money, I could have a good education. Basically, money gets you anything you want. I wish I could belong here. Being British I guess means that I get a British citizenship. I can get married here and have a family and children. In my spare time, I shall do what the people in this country do. If they go upwards, I'll go upwards. If they go downhill, I'll go downhill.

When the term 'home' carries the meanings of peace and safety, yes, I feel 'at home' in this country. It feels lovely. Here you don't have worries, you don't have problems, but you also don't have anybody to share your concerns with and to give you advice. The person who is close to you and knows you well can tell about your personality. I reckon a person cannot give an accurate description of himself. You always wish that you be a good person. I would like to get my twisted tooth fixed properly and to fill the gap from the missing one. The people here see me as I look.

(Translated from the Arabic)

TARNYA
BORN 1990, LONDON; ARRIVED IN MARGATE 2004
LIVES IN MARGATE

At first, my life changed because all the arguments stopped. Everything was really good. People in Margate are nicer. In London there was some really horrible people, like my brother's mates. They always started on everybody. They threw flour and eggs at our house. I thought it was really bad. Then something happened.

My brother couldn't find no work or anything. My sister was getting bullied in primary school by a lot of girls. And my mum and dad wanted to come down here because they thought it looked good. Some people might be able to make fresh starts, but we can't. We just went back to normal and then it got worse, how it was in London, loads of arguments.

I have one brother and one sister. My brother's eighteen and my sister's ten. They both live with me. They were happy about leaving. My dad didn't mind because he would be going up and down everyday. My mum was alright about it, but when she got here, she didn't like it. In London, we had friends really close by. We could just walk to their house, if my mum wanted a chat. She found it hard to make friends when she was here and didn't have a job. But she's alright now. She's settling in. It took ages.

Now my mum works in a kitchen in all different schools in Kent. And my dad travels up to London everyday. He's an electrician. He's really shy, not around us, but everyone else. He's quite, quite big so people are scared of him, like his workmates.

We came to Margate because my nana and grandad moved down here. Five weeks before we left, my parents asked me if I wanted to move. I said, "No", and then I thought about it, because I didn't really like my brother and sister getting bullied. I said, "Yeah", to make them happy, but I was really upset. We looked around and saw some really nice houses. It looked good, but I didn't want to make new friends and that. I just wanted to have the same friends all my life.

It was really upsetting before I left, everybody had the hump with each other. There was an argument between us all at school. So the next day, I didn't go to school. I just wanted to forget about what had happened. Finally, I went in, and they were alright. It was really, really upsetting. And everybody was crying.

I stayed in London with my dad the night before we moved into our house, because he had to sort the dogs out. My grandad picked me up and took me to his house. The journey was boring and long. I was sad and happy at the same time. Sad, because I was leaving our house and happy, because… just happy. It was fun going up London alone with my grandad. I brought pictures of all my friends, my signed jumper and the book I had with all my friends in it.

The house is quite big but not that big. My room is small. In London my room was massive because it was the loft. I like having a small room because I can just go in there and find everything.

I don't really have anything that's mine. I sit in my room and listen to my music or read. I like reading Jacqueline Wilson's books! I've read all of them. I don't know what I'm reading now, *Dates, Mates and Great Escapes* or something. It's a little bit good. I listen to all kinds of different music.

I was meant to ride horses, but no one could take me, because my dad is at work and my mum sleeps really late. In Kidbrooke, I rode Flame and Easter. I didn't like cleaning their mouths though. I liked show-jumping. That's how I got the rosette. It was fun and I didn't have to think. I just thought about what I was doing and didn't worry about anything.

I think I'm caring, that I care about people like my family. At school people think I'm always happy because I smile. I am not usually upset. I don't enjoy school, but I enjoy being with my friends. I wouldn't care if people saw me as a sad person, 'cause everybody's different. It doesn't matter if they think you're a bit weird. At home I don't usually smile. I don't think my family understands me. I don't talk to them very much. I don't think they know if I'm upset. They just think I'm moody.

I think I've changed. I've become more confident. In London one of my friends was always there if anything happened. She always used to sort it out. Here I didn't have anyone to sort it out for me. If anybody said anything, she always would say something back. When I was five, I had an eating disorder and she was there. When I grew up, she always used to make me eat even if I didn't want to.

I had a dream that I was living in this house, my new house, but I had the same primary school and same old secondary school. I lived half in Margate and half in London. It was really cool, because there are people I like down here and people up London that I like, and we were altogether. We all got on well.

So it is like I have two lives. I wish I could always see people together, if you know what I mean. If I drew a map of my life, it might be a big, really bumpy circle. It sort of goes up and down. I'd put in things that have happened in my life and things mum has told me from her life, that have made her the way she is. So it would be really confusing.

URYI
BORN 1995, BELARUS; ARRIVED IN MARGATE 2004
CURRENT WHEREABOUTS UNKNOWN

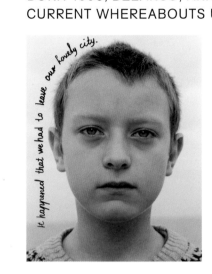

My name is Ura, Uryi. I came from Grodno in Belarus. It happened that we had
to leave our lovely city. Now we are living in a beautiful English city, Margate, which is
by the sea. Every day, my mum and I walk by the seaside. I love this place, but I am
always thinking about my grandmother and my friends.
Grodno is not very big, but it is very beautiful and green. We left because we had a
lot of problems, but I don't want to talk about it. We travelled by car. I don't remember
it, because I was very sleepy. I brought my bag from Belarus. And our neighbours
from Grodno gave me a small silver teaspoon as a keepsake. I left my soft toys that I
really loved. I also left behind my very favourite toys. I had toy cars and a constructor
set. You call it Lego.

Grodno is not very big. There is only one zoo in Belarus and that is in our city.
There are lots of animals and birds. I like living nature but I haven't been in the park for
a long time, because it is very painful to look at these animals and birds in a zoo.
Every summer, we used to visit another park with my grandmother. Near her house
there's a forest and a river. I had lots of friends there too, more than at home. Me and
the other boys always loved going to the forest to pick berries, and when there were
no berries, we liked to play football. In winter we played and slid around in the snow.
It was great fun and I usually came home with snow on my body and wet clothes. We
also liked baking fish in the coals of a fire. You take off the skin, then cut its stomach.
Take all the stuff out of the inside, put spices on it, then leave it for three minutes so
it gets spicy and then wrap it in tinfoil. When the fire's gone out, only the coals are left.
It comes out delicious. You can even eat the head and tail!

I didn't know we were leaving. It was just a week before that I found out. My mum
probably wanted it to be a surprise for me. I hoped for luck and success. I helped
pack. I handed my mum the clothes and she put them in the suitcase. It wasn't nice

to leave my hometown. I thought England would be my second country, my second town. We studied English at school. And we read a text that said it was very good in England, very clean. Red buses, kings, queens...

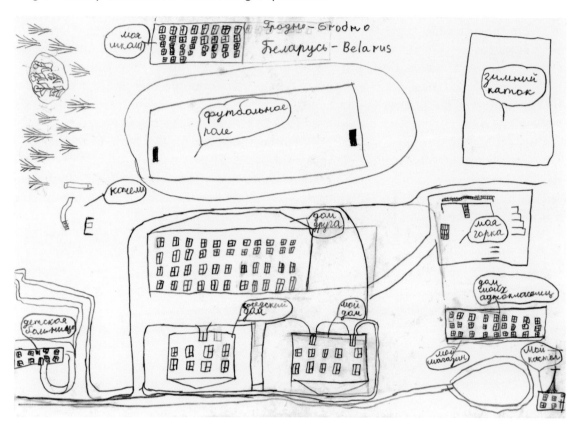

A bus picked us up and brought us to Margate late at night. The next day we went outside and saw nothing but the sea and the beach. Then I saw houses and shops. I saw the clock on the pier for the first time. We went to the pier where the clock is and where ships stop. There are such beautiful ships there. I kept staring. There is an old chapel there as well. If you go behind it, towards the sea and then straight on, there is a very beautiful place with a lot of flowers.

I feel very happy because there are very good places here. The flowers and the sunset remind me of where I'm from. We were sitting outside yesterday. It was night already. Then suddenly I saw from behind the clouds, black, black clouds, the moon is peeping out.

I'm a good boy. I am very kind to animals. I really like them. I'm very good at using a computer without any help. Sometimes, I like to make something out of plasticine or draw.

My eyes are probably blue. My family consists of my mum and granny. My mother's always with me. Her name is Elena. If my friends had some questions or problems, she always tried to help them. My grandmother's name is Stefania.

She is very kind. I love her so much. She likes making tasty things, very good pancakes. She especially likes making potato pancakes. I used to visit her at weekends and holidays.

I have this police dream. I remember it even now. I was fine and suddenly I got a call from the operator. It was a bank robbery. I drove very fast and suddenly I saw two robbers in masks running from the bank with guns. My colleague got out of the car and shot at one of the robbers. But the other one shot and killed him. They got into the car with a million dollars. I decided to chase them and overtake them. I stopped my car in front of them. They tried to get their guns, but I was faster. I shot them both in the shoulders. Then I used my walkie-talkie to announce the news. My colleague was buried and decorated posthumously. And we took the money back to the bank.

I had the dream in Grodno, but here I have no dreams. I don't remember my dreams. I left my grandmother, my best friends and my neighbours there. Sometimes I speak to my grandmother on the phone. I say a few words to her, ask her something, and that's all. Then we hang up, because it is very expensive to call.

I don't want to lose my granny, my cat, my lovely cat, and my friends. I have to change language, Russian for English. I'm really sad about it, but I'll never lose my language. I can't play the same games as I did at home. I'll have to have different customs. I'll have to do what mum says and study.

I haven't been able to do any of the things I like here, except running. I want to go to Dreamland! I want to go to school as soon as I can and to make my own friends. That's all.

When someone from the hotel looks at me we kind of greet each other straightaway. I like it very much. It is very good here. It's a fine, good hotel.

The people in Margate are good, kind, nice looking. When my mum and I go shopping, we always see a lot of people.

Nothing frightens me here. Well, I'm afraid of bumblebees. I think I am safe here. There are many people who can protect me. I think that in the future everything will be fine. I want to stay here.

(Translated from the Russian)

ZAAKIYAH
BORN 1996, SOUTH AFRICA; ARRIVED IN MARGATE 2003
LIVES IN MARGATE

Donderdag 30 September 2004

I was six years old when we left. I had my seventh birthday in Rugby. And then I had my eighth birthday in Margate. It was sad to say goodbye to all our family and friends.

The plane was nice actually, but I felt quite sick, because there was no proper air. There were loads of people and everybody was breathing in and out, so you couldn't get any fresh air. I brought my toys, all my dolls and my clothes from South Africa. On the way here I brought a little bag with me at the airport. It had small dolls with it, so I played with my small dolls. And it had a fruit shoot in it and a pack of crisps.

When I left South Africa, it was quite warm and I was sweating. When we arrived in Rugby, there was thick snow. So we made a big snowman. We borrowed some movies from other people. I liked the T-shirt my mum bought me there. It had a big collar on it and comes to my knees.

I don't like South Africa, because there are lots of bullies. The people made me scared. I didn't like the spiders. Once I was coming into the toilet, I looked up on the roof and there was a spider as big as my dad's hand. When my dad killed it, he took this bug spray and sprayed on it, and it just crinkled up. Then we chucked it in the bin. I thought it might come alive again and come into my room.

Once, right in front of the house, two people were fighting with each other. They said they were going to stab each other's necks and then kill each other. Then one started pulling the other man's ear. Somebody called the police and they went off down onto the street. I was looking out of the window. I was really scared.

I didn't think it would be like that here. I thought it would be a nice place up here without any bullies and people that scream. Some people at school call the

other people names. I ignore them and tell the teacher straight away. Makes you feel scared here.

Our first house here was right next to my mum's work. And she had to be in nine o'clock. She always used to be late, because she used to blow her hair and everything. Sometimes she lies down and reads a book. That's what makes her late.

I think we came over to Margate when it was Christmas. The houses were decorated and all the decorations were in the street. I liked my room, because I was next to my goldfish. Every night I could see six goldfish. I had two first, but one morning, I woke up and one of my goldfish had died. Then we bought six more and put the other one with the others. From that day on they just kept dying, even though I followed the instructions and did everything properly.

I think people see me as normal here, but sometimes we dress like South Africans. We wear these Billabong and Quicksilver clothes, surfing clothes. I have this dress that comes from South Africa and it's got little stripes around it. I can't see anybody wearing the same dress as me. In South Africa we spoke English and sometimes Zughdie spoke Afrikaans with me. Because we went to a Muslim school, we used to learn Arabic. I can say a few things in it, but I can't speak it. I go to the Madrassa school here.

I actually know more words in Afrikaans than my brother because he doesn't normally listen to my mother and father's conversations. I'm watching TV and then my father turns the volume down and he speaks in Afrikaans and I just listen. I can't listen to the TV, so I have to listen to something.

Something I don't like about Margate is, every time you come from somewhere else and you don't speak the same as them, they make fun of you. I think they're actually strange to speak like they do, although now I can speak a bit like that and I don't think it's so strange anymore. I think the people that make fun of us are probably jealous or they have a lot of anger. Probably someone's been picking on them and then they pick on other people. Because I watched The Simpsons and Bart's best friend turned famous, and he moved away, and he just wanted to act cool in front of his cool friends. But the kind people here make us want to stay.

In South Africa, the people don't make fun of your accent. They wouldn't really mind if you came from France or somewhere else. They'll just ask you loads of

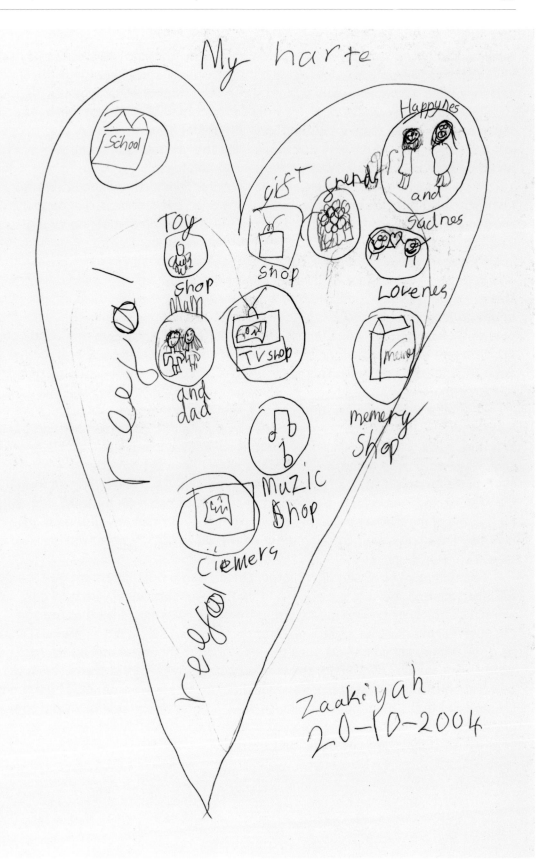

questions. All my cousins when we came back from England, they were just asking us questions: "How much? How hot is it there? Does it snow? How was the snow?" And they keep asking us to teach them some English accent.

My mum's a social worker. They asked my dad to teach all of the children in foster care because they are all Muslims. The foster care mothers and fathers were not Muslim, but Christians. My dad was telling the children stories about our Prophet and they actually told him that they wanted to be Muslims.

I don't think they have Muslim schools here. That's something different. I actually liked the Muslim school, but not the one I used to be at. It's because they used to get this big stick and hit you on the hand if you do something wrong.

There are lots of Muslims and some Christians in South Africa. Zughdie and me knew what we could eat and we'll never forget that. We didn't have to ask our mum and dad if we can eat that. Up here, if I just want some crisps – and I always want crisps – I always ask my dad if these ones are right for me, because I'm not allowed to eat ham and maybe those are ham ones. It's part of our religion. Because this person Mohammed, he was the last person made, I think. He told everybody about our God and told us to believe in this God. He said that Muslims are not allowed to eat ham and pork and stuff. They believed him. They didn't eat it. The religion is always with us.

I don't want to lose my family, really. We phone them and sometimes we go for holidays there. My dad, he always phones every night to see how's his dad because he's in hospital. I am worried about him because my dad says he's on his death age now. He always used to make fun of me, saying I have big, fat cheeks.

In South Africa, my dad painted my room. First it was pink, then he found the star sponge, dipped it in the paint and started to dab it on the wall. It looked nice. I left some of my clothes there. When we went there to visit, my grandma gave me all my baby shoes. I've been sticking them on my wall like they were walking. Two over here, two over there...

Sometimes I have bad nightmares. Once I had a bad nightmare that the spiders attacked me and they ate my body. And all that was left was my scalp. I only saw when they came all around my face and then I just woke up. I went to my dad because I didn't like that nightmare. Sometimes when I have a bad dream, I make up good things, but when I go back to sleep and I'm all better, my bad dream carries on. If I want to think of nothing, so my mind can go away of the dream, I just think of a blackboard with nothing on it. Then I just close my eyes. Sometimes I don't have any dreams and that's quite boring because when I go in sleep I actually want to have a dream.

I'd describe myself as funny and scared.

ZUGHDIE
BORN IN 1993, SOUTH AFRICA; ARRIVED IN MARGATE 2003
LIVES IN MARGATE

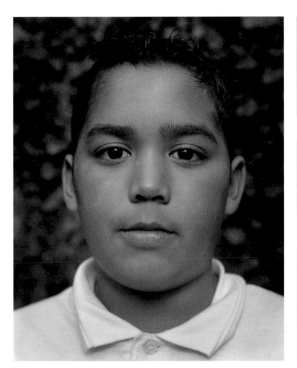

There was excitement when we left, because we'd never been on a plane before and were excited to get on. I felt sick for the last plane because it turned sideways and you could see nearly down to the ground, it turned so hard. After we took the plane, I wasn't scared of any roller coasters. Sometimes, I make up jokes about when I'm high up and I'm balancing. Then I'm scared. In South Africa, we used to walk on our walls, and it's really thin and really high. That was scary.

I'm eleven years old and I come from Port Elizabeth. My mum said we should visit different countries. My dad thinks we should stay here until we finish school. I'd like to stay here because it's much more exciting than South Africa.

My brother wants to be a car designer. He first said he wanted to do motorbike racing. My dad said, "If you want to die young, you can be a motorbike racer!" I chose football instead. I dream of playing for Chelsea when I'm big, up front. I want to be a striker. My dad says my sister must be a doctor.

I dream about football or I dream about going to South Africa. When we just get on the plane, then my dad wakes me up. I just close my eyes and do a fast dream, like I got to South Africa and played with my cousins.

It was sad because my friends were all there, and then we decided to leave. First, we went to the airport and said goodbye to our family, and my grandma was then crying. We got on the plane in Port Elizabeth. Then we went to Johannesburg, we switched

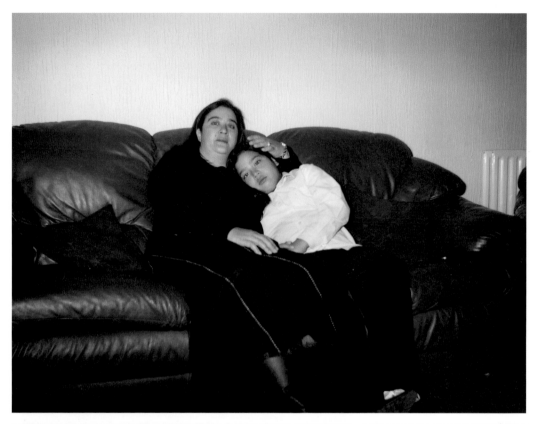

planes there. Then that took a night to get to France. From there we went to
Heathrow. We left the one day and got in England the next day. I brought my South
African flag, my South African hat and two Woody dolls. I think I forgot the rest. Me
and my brother and my sister was just racing to get outside, to touch the ground
of England, to see who was first.

We went to Rugby to live there by a farm. My mum's work gave us that place to
live for a few months until we find a house. Later my dad hired a big van to take our
things to Margate. Then he came back, about half six in the afternoon. We had to get
in the car and my grandad had to drive us. It took three hours.

We feel at home in Margate. It smells like South Africa when my dad cooks.
We eat South African food. If you go to certain places and you just look at the
houses, it looks nearly the same. Some people like South African things here as well.
Like my friend, he always asks me to teach him words. I told him how to say "Good
morning," "Good afternoon", "Don't speak," and "I'm going to punch you."

We speak English, but my mum and dad talk to our family and to each other
in Afrikaans. I can say some words. And I understand it perfectly. Sometimes,
I understand when they're on the phone. If you want to talk South African you don't
need an accent. You just talk normal. I know when I'm changing from one accent
to the other. I learned it from my friends.

Sometimes here, I'm scared here when people keep on swearing and all of that
lot. I was riding from Blockbusters when I dropped my game that I hired. These people
came to get me, took off my phone and said I must go home. They were eighteen
or something. Then my dad went to get it off them. First he did hit one guy, with a
little punch, so they just threw the phone back at him. He called the police.

In my dream, I was going for a walk. And we all ran away because this guy had
a gun and shot my dad. I just woke up and then I made up the rest of the dream, like
my dad went to hospital and he got better. When I have bad dreams I just make up
stuff to make it better.

Some people here are kind and the rest of the people are like naughty children
and drunk people. It's alright, though, because it's only the naughty people that call
us names, that make this place a bit unsafe. The kind people are alright.

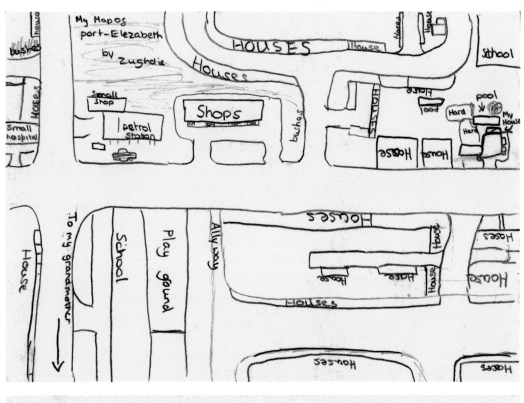

My Map of were I stay
in port-Elizabeth

by
Zughdie

TOWARDS A PROMISED LAND
BY WENDY EWALD AND MICHAEL MORRIS

M How were the parameters of such an ambitious project first mapped out?

W I visited Margate about a year before the project actually began. At that point we had no idea who we were going to work with. We walked around and visited schools and groups and institutions; we went to the mosque; we met kids who were caring for adults. It was very interesting, overwhelming actually, as there were about ten different groups I could have worked with.

When I visited Northdown Primary School, the principal told me that there was a 50% turnover in the student population *every year.* That was amazing to me, that a town could change so much in one year. With that statistic, I began trying to focus on the experiences of people starting their lives over in Margate and what those experiences were for children, in particular.

Although the coast of Kent has been the gateway to the U.K. for asylum seekers over many years, I didn't want to limit my attention to foreign immigrants, because it was obvious that the 'flood' of asylum seekers was something of a cliché. The Nayland Rock Hotel, formerly one of the town's grandest hotels, now houses asylum seekers, who some Margate locals see as having a free ride while everyone else struggles. So I decided to develop a project with the broad idea of what it is for kids to start their lives over, whether fleeing war-torn places or being moved by parents from one part of the country to another. I asked the principal at Northdown Primary School and the assistant principal at Hartsdown Secondary School to identify British kids who had moved to Margate. The Nayland Rock Hotel was the obvious place to work with asylum-seeking kids, as well as the Orchard Centre (the real name of the centre has been withheld to protect its inhabitants) where unaccompanied immigrant minors are housed. These four groups formed the matrix of this project.

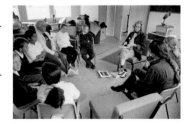

M What kind of community did the children represent for you? Did you discover common threads in their diverse experiences of departure and arrival?

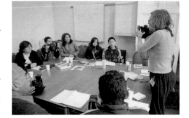

W Some of the kids from Northdown and Hartsdown schools had come to Margate just months earlier, some more than two years earlier. They were acquainted with each other

but weren't necessarily friends. They came to Margate because their families needed to make a change: Gareth's father wanted to get away from sectarian violence in Northern Ireland; Lanny's mother left Wales quickly to get away from an increasingly abusive relationship, and so on. The kids at the Nayland Rock Hotel had arrived with their families within the past few weeks. I was privileged to be able to stay there for some weeks, to get to know people and see how their lives were unfolding in this new situation. The unaccompanied kids at the Orchard Centre were in a more extreme situation. Most of them didn't even know that they would end up in England.

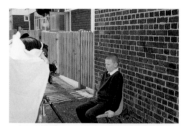

For the most part, the kids in each of the four groups didn't know each other before we made this project. They came together by working and sharing and comparing experiences. By the end, I certainly felt that I was working with a community.

M How aware were the British kids of what it means to be a refugee or asylum seeker?

W A couple of the younger ones had heard the term but weren't sure what it meant. Reece talked about how it disturbed him not being able to communicate with a Chinese man in a restaurant; and Max talked about how the refugees had to leave their countries and it wasn't their fault.

M But they didn't identify these experiences with their own sense of displacement?

W It was only when we began to look at the pictures and read the testimonies of the asylum-seeking kids that the British kids really recognized that they shared experiences. They said, "Oh yeah, I brought this with me, just like Christian". They realized that Christian was the same age as them, and that although he had fled something much more difficult [the war in the Democratic Republic of Congo], they all had similar reactions in terms of what to take with them and what to leave behind.

M What happened when the different groups of children met each other for the first time at the launch of the first set of banners?

W The Northdown kids kept saying about the refugee kids, "We want to hear more of the sad stories". They recognised themselves to be more fortunate.

M And how did the refugees react to the notion that the British children had also experienced upheaval through relocation?

W I think it was more difficult for them to understand. It

wasn't until they met at the exhibition at the Outfitters Gallery, and saw the suitcases that the British kids had used in their installations, that they understood the connection.

M Were the asylum seekers more articulate?

W As we were working through translators, this was not always evident. It took longer to teach everything to the asylum-seeking kids, but once they were on their way, they displayed more confidence than the British kids, possibly because they had survived incredible and difficult journeys. The British kids seemed to be complicit with their family's need to make a change. Many of them described themselves as annoying or naughty. They hoped their behaviour would change once they came to Margate. Tarnya worried that new starts were impossible for her family. The asylum-seeking kids were, by and large, bright, sophisticated and more worldly, like Elisio who had escaped from Angola with his mother and younger brother, leaving behind his sister and his brother.

M Did they perceive Margate as a place where different generations of migrants had settled?

W Vaguely, but I don't think they had any sense of British history. They were in shock, so I think they were living in the present and thinking about what was going to happen next.

M Do you think this tendency to live in the moment is typical of children of this age anyway?

W In my experience, kids who are settled have a much easier time fantasizing about realities other than their own. For example, the kids I worked with in South Africa in 1992 refused to photograph their dreams. For them, to imagine something was to imagine something dire. I was surprised that certain of the kids we worked with in Margate were able to talk about their journeys and to make photographs of their dreams or fantasies. The asylum seekers spoke about feeling safer than where they had been. At that point they were all very hopeful and their scars weren't necessarily visible.

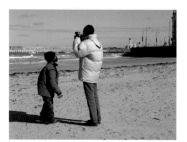

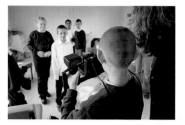

When we invited the kids to return for the launch of the banners, Elisio and his family were the first to get their tickets from Nottingham to Margate via London. Unfortunately, three days before they were to leave, the 7/7 bombings occurred. The news triggered memories and fears in Elisio of his ordeals in Angola. His mother and little brother tried to reassure him. Finally he agreed to come only when an Artangel intern who spoke Portuguese said that she would accompany the family.

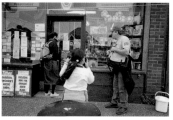

M How do you feel that this project relates to your earlier collaborations with groups of children?

W I had
worked on a project in Richmond, Virginia in 2003/4 with kids who were
living in an historical African-American neighborhood on the edge of a large,
predominantly white university. Richmond had been the capital of the Con-
federacy during the American Civil War. The main avenue is lined with stat-
ues of civil war heroes, so I was interested in playing off that, making my
African-American students visible to the white community around them and
to the adults in their own community. I made huge portraits of them, meas-
uring three by four metres, and installed them on local buildings. The pho-
tographs marked the boundary between the two communities.

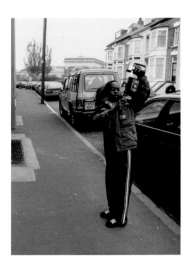

M And what
was the response from the Richmond community to this project?

W It was over-
whelmingly positive. We had to get the permission of local businesses and
house owners to hang the banners on their buildings. No one turned us
down; some even competed for particular images to be hung on their build-
ings. The Carver Community Association organized a celebration with
dancing, music and a barbecue, to launch the installation. Although Carver
buildings were frequently tagged with graffiti, the banners stayed up with-
out incident for over a year. Money was raised locally to produce a cata-
logue and the commissioning arts organisation and I received an award
from the city.

I thought that this same strategy could be interesting for Margate, where
people coming to a new place were invisible to the residents of that place.
To make them visible in a monumental way around the town would be inter-
esting and provocative.

M Are there any similarities between Richmond and
Margate as contexts for your work?

W Not really. Richmond has a coherent
African-American community that could support my project, whereas Mar-
gate is very fragmented socially. None of the kids I worked with had a clear
constituency in Margate, so it was important that the people of Margate
embraced the project. I wasn't sure if this would happen.

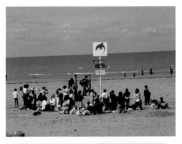

M At the outset, you
involved each of the children in the same way. Can you explain the process
of working with them?

W First, I made portraits of them with my large-format
camera. I also made Polaroid tests so that they could suggest changes
before I shot the final photograph. At the same time, I taught them to use a
Polaroid camera and positive/negative film, which is quite complicated.
They had to measure the distance between themselves and their subjects,
and carry buckets of sodium sulfite in which to dip the negatives. This

slowed down the process and gave them time to think about what they were going to photograph.

In the second phase, I asked them to identify objects they'd brought with them when they moved, so that I could photograph them for the banners. It was fairly easy for the British kids, because the things they had were precious objects, like Lanny's Mr. Bean collection or Gareth's inflatable Red Hand of Ulster, or whimsical childhood things, like Gemma's stuffed pig. For the most part, the asylum-seeking kids only had more practical things, like a suitcase or clothes. Some felt they didn't have anything that could be used.

During this time, they were also photographing their surroundings as well as their dreams and stories, if they wanted to. Towards the end of our time together, Lucy Pardee, the initial researcher for the project, interviewed them, helped by various translators. Some of the kids also made maps of where they came from and of Margate. At the Orchard Centre, the kids drew different things. Reza drew an ornate bird perched on a pen. He wrote on the back, "The pen says, 'I'm the king of the world. Whoever is the pen-holder, will be given power by me'". They talked about their journeys but they didn't make maps of them.

M Was it because the particularly distressing nature of their journeys made the emotional memory too difficult to chart? Perhaps *not* mapping the journey was a way of leaving it behind.

W Yes, it could be. The only kid who did do something like that was Long, a North Vietnamese boy, who lost his father during the journey. He made a drawing of his father at work, a second one of him going to school, and a third one of them together in front of what appears to be their house. For most of the kids there was no map to make of where they actually were, because they didn't really know.

M In general, what was your impression of how newly arrived refugees were treated in Kent?

W It was such a difficult situation, both for the asylum seekers and the people who were working there with them. Although the asylum seekers were given quite a lot, we all felt that they needed so much more. They were living in rooms with TVs and that was their reality. The kids at the Orchard Centre were dying to go to school and learn English. I'm sure they would have felt much better had they been able to be more productive There was an art room in the Nayland Rock Hotel, and at the Centre they were actually given packages containing cameras, but no one really worked with them on creative or educational projects over a period of time. The general feeling was that it was a waiting game.

There was a siege mentality at the Nayland Rock Hotel. People didn't want to go out, because if they missed an official appointment they risked losing their meals or shelter. They were also nervous about their reception outside and were told to be careful. We took walks with them to make photographs. They loved these walks, the beach and the shops. Margate was their first glimpse of England.

M The children at the Nayland Rock Hotel came with parents and family members, but the children at the Orchard Centre arrived alone. Were they different?

W The kids who had come alone were tense and deeply uncertain. They were being told what to do. They didn't understand the system and they couldn't speak the language. So the translators became very important to them, but they weren't always around. With these kids, I felt a sense that something was always about to happen; everyone was on edge all the time. The other kids were worried too, but at least they had adults and families with whom they could discuss their worries. One important aspect of their identity, their relationship to their family, was still intact.

M Did this create a difference in how they related to you and the project, and how they talked about their experiences?

W At the Nayland Rock Hotel, the kids' stories were largely told by their parents. The unaccompanied kids were more open, although they could also be quite suspicious. For example, Reza stormed out of the room in the middle of his conversation with Lucy because the questions she was asking reminded him of his interrogation at the Home Office. By stopping the interview, he was taking control in a way he couldn't with the Home Office. Eventually he relaxed and told his story. Obviously, he was happy to take photographs or draw, because he could be in control of the language.

Once these kids got their confidence with taking pictures, they could be both very playful and deadly serious. Long made a series of pictures of a mock execution; Omar played the victim; and so on. They had a wonderful time setting up the pictures, crafting props out of kitchen implements and whatever was at hand. I recognized this kind of image from my experience with other kids I'd worked with whose lives were safe and comfortable, so I wasn't worried that these images signaled deeper problems. Omar said that it was the best week of his life.

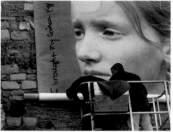

M When you met these children, did you have any sense of how long you would be able to work with them?

W No. We had to work very fast and flexibly to do as much as we could, because the kids could be relocated at any time. A list was posted in the hotel once or

twice a week with families' names and their resettlement destinations in England. The families never knew when it would be their turn or where they would end up. Four days after we began working with Mariam, her mother found out they would be moving to Leeds the following day. We hadn't interviewed her, nor had she had a chance to take many photographs or tell her story. We worked with her as quickly as we could on her last day. Rabbie and Celeste were the next to leave, suddenly.

M How did you edit the texts of each child? What were you looking for in each case?

W To describe where they came from, why they left (if they'd talk about it), the nature of the journey, and their reactions to it (some of the British kids said that they didn't remember the journey, just the arrival), their impressions of Margate, what they thought their future would be there, and so on. Many of the kids talked about what it was like where they came from, the things that they left behind, what they missed. Some of the kids also wrote pieces, which I folded into the interviews, as well as anecdotes that reveal their person-alities.

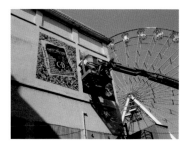

M What is striking is that humour plays such an important part in all this; perhaps as an indication of hope.

W Yes, like Christian thinking that the Queen would invite him to tea, or wondering whether someone had been bad at the opening of Parliament, as they banged the door. But these anecdotes are also very telling about how they are trying to unlock what is around them. But the situation was very difficult for most of them: they felt the cold; Elisio's mother had diabetes; Christian's mother was ill; and so on. The kids seemed fine, but their parents were often physically troubled and stressed about their future.

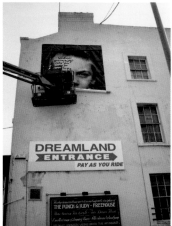

M Did they feel that this project was a kind of welcome for them? For some of them, it was the first time that anyone had shown interest them as people, rather than as statistics.

W I thought about that a lot when I was photographing them, about working against the process of objectification. Strangely, I was asked if I had chosen the kids on account of their beauty. For me, it was more a case of finding a way to get them to open up for the camera. I think this openness is tantamount to beauty.

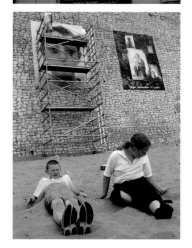

M How many of the children seeking asylum have succeeded since you initiated the project?

W As far as I know, all of them have been denied asylum at least once. That is shocking to me. Many are appealing for reconsideration. Christian's mother finally feels confident because she has a good barrister.

But some have disappeared.

M Statistics say that half of all applications are accepted, but that doesn't appear to have been borne out here.

W It is already more than a year and a half since we began this project and all these kids are still living in limbo.

M Is counselling or psychological support offered when they arrive?

W Not that I could see. It might have been offered at different stages.

M So the psychological and emotional impact of all this on a child who arrives without parents is not being measured.

W No, nor of those with parents. They seem to do quite well in school, except that they take on so much. As well as school, they have to help their parents through their problems, help with language and so on. We went to see some of the families that had been resettled, which was very interesting. They were doing so much better on their own and making connections within their communities. The kids were much calmer and in command of themselves, and they were going to school. Going to school is key. In the beginning, the intensity of Uryi's attachment to his mother and to us was worrying. His hugs were so strong I thought my ribs would bruise. When we went to see him and his mother in their new apartment in North Shields, I braced myself for another bear hug. But instead, he opened the door and waved to us politely and warmly from the stairs.

At the Nayland Rock Hotel, Christian wouldn't eat. We also thought he might have a learning disability, as he could never figure out how to focus the camera. When we visited his family's new high-rise flat overlooking the Clyde River in Glasgow, he was watching *George of the Jungle.* He was noticeably calmer and more focused. He told us he'd moved from year five to year seven at school and his English comprehension was good. He had made a close friend at school, a Pakistani boy with whom he spoke English. His mother told us that when she got discouraged, she relied on Christian's optimism and reassurance.

M Would that be true of the British kids too?

W Yes, in certain cases. Tarnya had to be very supportive of her mother, who found it very difficult to adapt to Margate. Tarnya's school situation was separate from her mother, but it was hard on her all the same.

The asylum-seeking kids don't have the same opportunities to talk about hardship because, paradoxically, it is their survival. There is a great deal of pride attached to this and their accomplishments are incredible, really. In Kurdistan, Omar never had the opportunity to learn to read or write Kurdish because he worked as a labourer to support himself and his sister, rather than going to school. In Margate, he learned to speak English fluently in just a few months.

M Did any of them express a desire to return to their countries of origin one day?

W A couple of them talked about going back sometime. But none of them seemed to want to go back permanently, except for Zughdie and Zaakiyah. In Margate, things had not been as smooth as they had imagined. They talked about a level of tension and chaos and aggression that they hadn't expected, so they thought that South Africa would be just as good.

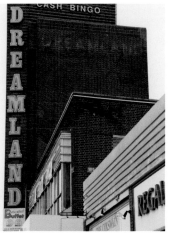

M When it was time to say goodbye, did you notice differences in leave-taking between the groups?

W With the Hartsdown kids, who were teenagers, it was a low-key affair. We were taking a walk and the kids went one way and we went the other. With some of the other kids, there was definite ceremony. The Orchard Centre kids all wanted photos of the others. They made speeches and so on. We didn't initiate any of this. The kids at Northdown were very sad, hugged us all, came out and waved goodbye. With the Nayland Rock Hotel kids, there were goodbyes all the way through, because some of them left during the process. We made albums for each of them as a record of their arrival in England. Sometimes this meant frantically trying to get them ready the night before they left. At the end, Uryi and Christian were the only ones left. They came to the station. Uryi was crying. It was very emotional. Now Uryi is gone too.

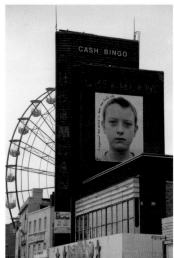

M Was there a sense that saying goodbye had come to characterise their limited experience of life?

W Yes, and that's why it was great to go and see them again. Except that then we lost track of Uryi. When we were planning the first hanging of the banners, we called Uryi and his mother Elena on their cell phone. Elena's English was still not good, so Uryi explained that they had been removed from their home in North Shields and put in a detention centre, because they were late filling one of the required forms. They were no longer in the detention centre, but in a hotel near Heathrow. He thought the Home Office would find them a new house soon. We made an appointment to meet them the next day, but they didn't show up and we were never able to contact them again. We fear they've been deported.

M Have you had this experience in other projects, of losing touch with the children with whom you have worked?

W Not in such a sudden and dramatic way. In this case, it was not their choice to lose touch. They wanted to keep in touch because there was another part of the project, the launch of the public banners, which would bring us all together again. Happily, we were able to meet many of the kids at intervals during their first two years in the U.K. Each time we saw them they were more at ease and more assimilated. Elisio joined a football team; Reza moved into his own flat; Christian was able to see his sister again who was studying to be a lawyer. Their stories keep evolving.

M How did you transform all of the research material, both transcribed interviews and photographic images, into the final project?

W I edited each interview transcript to make a more or less coherent story. Then I looked at each kid's interview with him or her and we picked out some lines that best described his or her journey. We decided how to position the texts over their portraits, then they wrote the texts on Mylar sheets placed over the photographs. By now, the asylum-seeking kids could speak English, but for Omar, who had never learned to read and write Kurdish, it was a challenge. He had rarely even picked up a pencil, so when asked to make a drawing, he traced his hand and filled it with cut-outs from a magazines. We read him the sentences and he chose, "When I was younger, I had no worries, but when I grew up, I started to think of life and I am a human as any human, no more." To write his sentences he held the pen tightly almost at the bottom. He pressed the pen down so hard that it squeaked as he copied the sentences, letter by letter, from the paper on which I had written them.

M And how did you choose the eventual sites for the banners?

W From the beginning, I wanted to hang the banners on the cliffs so they would face out to the sea, from where many of the kids had come. Or, if the photograph was of the back of the head, it would be positioned looking back into Margate, where the kid had arrived. I also liked the idea that the portraits would start out at the sea's edge and gradually make their way into Margate over time. The kids were also interested in hanging the photographs in Dreamland, adjacent to the sea wall. This made sense, since part of *The Margate Exodus* would be set there. Finally, I wanted the banners to move even deeper into the community, so we installed them on the public library and a house on Thanet Street.

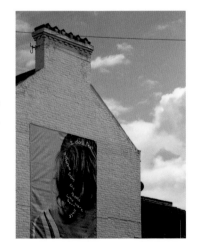

M It is now more than one year since the first public images of the children and their belongings went up along the sea wall. How do you feel the local

response has been in Margate?

W One of the reasons we decided to put the pictures up in phases is because we didn't know what would happen. We were aware of the tension that the presence of the asylum seekers caused. On one of my first nights in Margate, when Lucy and I were walking home to the Nayland Rock Hotel, we were egged from a passing car. But for the most part, the comments have been positive. When the exhibition was at the Outfitters Gallery, people could read the kids' stories and look at more of their pictures. Some people stayed for hours looking at everything and discussing the project, the banners and the issues of asylum. They were especially impressed by how well the kids presented themselves, how brave they were to present themselves in such an honest and sensitive way. Invariably, they sympathized with their life changes, although there have been incidents.

M Such as?

W Two of Zaakiyah's pictures were burned after the 7/7 bombings in London. Zaakiyah is a Muslim student at Northdown school who came from South Africa. Her installation comprised three images: a picture of her face; one of the back of her head covered by a scarf; and a third image of two copies of the book, *The Principles of Islam* and a pair of flip-flops, important possessions she had brought with her from South Africa. The vandals burned the front and back of her head but left intact the third image. It was tough for Zaakiyah and her family, but they handled it in a remarkable way. They didn't take it personally and wanted the banners reinstalled when things quieted down.

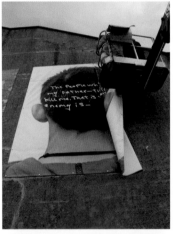

Kent has a history with the National Front. There is still an annual march in Margate, but in 2000 local residents, supported by the Anti-Nazi League, actually prevented the National Front, protected by police in riot gear and dogs, from reaching their rally point.

M How have the children responded to seeing themselves portrayed like this?

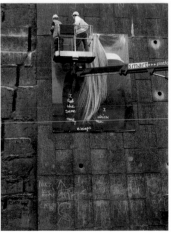

W They have been quite proud. Christian and his mother shouted gleefully when they were driven past his banners after the long trip they made from Glasgow to the launch. I was scared that they might have reacted adversely to the scale of the representation. I remember when I was about ten, my father who owned a Chevrolet dealership at the time, commissioned a billboard to be painted of my mother with the slogan "Ted Ewald is her favorite car dealer". This giant likeness of my mother on the highway was so disturbing to my mother's friends that my father eventually had to take it down! But this hasn't happened in Margate. Gareth clapped his hands over his face when he first saw his pictures and was quite shaken for a few minutes. Then he started to beam and his mother asked for pictures of the installation.

For the older kids it has been a bit trickier. We started the project over a year and half earlier. In that time, they have grown and changed. The London bombings happened. Regretfully, one of the boys withdrew from the project very late in the proceedings. He had become uncomfortable with the project and perhaps no longer wished to be identified as a foreigner. Gemma also asked that only the back of her head be shown. Of course, I agreed, although I missed the portrait on which she had written, "I just talk, talk for England". Unfortunately a local newspaper printed a copy of the picture. I was very upset and worried how it might affect Gemma. I went to talk with her at school. It turned out that many students had brought in the newspaper. She was the centre of attention and her mother had framed the article. She sweetly asked if we might hang it after all. Then weeks later her portrait was pelted with eggs and red paint. Again, I worried about the affect on Gemma, who had been bullied in the past, but the incident seemed to strengthen her. She was determined that 'these people' would not succeed in spoiling a project for which we had all worked so hard.

M

Perhaps because there has been so much positive feedback…

W Now that the banners are in the centre of town and on the sea wall, they have become a feature of the town. One local shopkeeper explained that the project was important because Margate is made up of so many different people. She thought that people grumbled about change, but once they understood something new, they welcomed it. The local librarian said the banners helped people to think about Margate in a different way. She was pleased that the arts were being used to change peoples' perceptions. Tulie, owner of The Joke Shop, and a self-styled community leader said it was wonderful the banners were so public, so everyone could enjoy them. "The children are our future", she said, "and, even though the banners are black and white, they brighten up the place."

But others have questioned the use of black and white images and the fact that kids aren't smiling. They asked, "Is this another grim image of Margate?"

MARGATE
BY ABDULRAZAK GURNAH

It was the summer of 1968, my first summer in England. "Hey Jude" was playing over the PA at the miniature golf course over which my friend John presided. We sat just outside the low shed that served as the ticket office. John could not even sit up straight in the shed, let alone stand, so he sat beside it and issued the tickets from there. On this evening in August 1968, he was keeping an eye on the youngsters and their dads putting golf balls under lights, all the while talking to me in a steady spate. He loved talking. I had been there all afternoon and the smells had changed as the air cooled, so that by early evening the aromas of seaside-resort food had lost some of their edge.

"Hey Jude" had been going most of the afternoon. It had just been released, and it played on the radio again and again without respite, or so it seemed, and no one grumbled. That is my earliest complete memory of Margate, sitting by the toy golf course in the early evening, listening to that music while John prattled. I know it was not my first visit, but when I think of Margate and that summer, this is the memory that comes up.

It had been a busy summer: the war in Vietnam, the assassination of Martin Luther King, May 1968 and its revolutionary hyperbole, Biafra, the looming invasion of Czechoslovakia. There had been other cruelties and other deaths in less visible parts of the world as well, as there usually are — coups, lock-ups, daylight robbery, the travails of lawless states. But there I was, legs stretched out on this mild summer evening in Margate, apparently oblivious to all of that, amongst the crowds of holidaymakers. John chattered away, and I pretended that I was not a lonely and homesick teenager a long way from home.

It was a hot summer. I had not expected England to get hot. The months I had spent here until then had been cold at first and then chilly, and I had assumed that was how England would always be, and the summer would be warm but with the kind of chill in it that you get at dawn in Zanzibar. So it was a surprise that the days were so hot, and that the sun blazed instead of shining between clouds, that it made me swelter. The painter William Turner lived in Margate and is reported to

have described the skies over Margate as the loveliest in Europe. I am not sure what a painter of skies would have meant by such a superlative, but the light that afternoon was bright in a hard-edged way that made the horizon draw near. As the air cooled with the coming of evening and the breeze from the sea, I wonder that I did not think to compare where I was to Zanzibar. Because I did not. England seemed so alien then, so unlike what I had known before.

I had met John in Canterbury where we were both students at the Technical College. He sought me out as we walked out of a class and fell into step beside me, huge next to me. After a moment he told me that he did not like 'wogs.' The word was new to me, although I had no difficulty in guessing what it meant. On our furtive flight to Europe (because my brother and I were 'escaping' from Zanzibar) we had changed planes in Brussels. As we waited for our connection to London, we sat next to two English men wearing pinstriped suits, business executives as we would call them now, and we stared at the sight of the pinstripes we had heard about but never seen. One of the men turned to the other and asked, "What are these niggers staring at?" John's 'wogs' had the same ring. In any case, I was soon to come to know a whole range of such words. I make light of it here, but these encounters were shocking, deeply unsettling and personal, even if the abuser was unknown to me. John was more or less unknown to me, and his "I don't like wogs" were the first words he spoke to me. I asked him why and he said because they smelled.

He would not leave me alone after that. He sat beside me in class even if I tried to find a corner to sit by myself. I liked to sit by myself. The railway station where he caught the train to Margate was on the way to my lodgings, and at the end of the day's classes he waited for me so we could walk home together. He was my protector against the brawling racist abuse that passed for teasing amongst the English students. And he invited me to Margate and to his home, where his parents fed me and spoke to me politely. They invited me out of curiosity, they said, because John had reassured them that I was not like other immigrants ('niggers', 'wogs', 'immigrants', take your pick), that I was civilised. I don't know what John based this on, but I was not so civilised that his parents neglected to tell me how much better off I would have been had I stayed from wherever it was that I had come from. It was not unheard of in 1968, in the England I knew, to be spoken to as shamelessly as this to your face, as if you were a beast without feelings. I lost John at some point. He joined the army and disappeared.

John was not my only link with Margate in those days. Most of the students I knew were from outside of Britain, several of them from the oil countries: Iran, Saudi Arabia, Kuwait. For a variety of reasons, they liked to live in Margate. Perhaps they had first arrived there when they came to England. Seaside resorts had established themselves as places to learn English, as a way of using the otherwise empty accommodation outside of the holiday season. Crowds of students from Europe and from the Middle East came to places like Margate and Brighton to learn English. Something about the brash gaiety of the seaside resort must have appealed, and several of the students stayed on in Margate while they continued studying in Canterbury.

To me, Margate seemed alien when I first knew it, because I had not known about this England. When I arrived in Canterbury, on the other hand, the town seemed recognisable, familiar from what I had read about England: the cathedral, the river, the beamed houses, the butcher, the baker and the policeman. Margate was noisy and crowded with people finding pleasure in trinkety games and loud pop music, a place where bands of youths fought incomprehensible battles on the promenade. Margate was Dreamland, from where, every Monday morning at college, came stories of frenzies and seductions, of escapades with the one-armed bandits and the excesses of pop groups that had performed that weekend. Sometimes there were stories of mini-orgies, of young women who agreed to have sex with several of my wealthy fellow students.

They blazed with arrogance, the moneybags students, especially the Iranians, who carried themselves with the same superior assurance that the Shah adopted in the royal photos. For this was still in the days of the Shah, who was well-known for his global ambitions, so he would perhaps have been pleased that some of his subjects had taken charge of a small corner of Margate and were seducing young women at will. Now, I wonder what went on in their heads. No doubt many of these stories were no more than sexual bragging, tales of dark-skinned foreigners humiliating young blond women who could not resist their wealth. But they made my friends' lives in Margate sound vivid and full (if without dignity or self-respect) compared to my poverty-stricken struggles in a stuffy lodging house. They made Margate sound dangerous and risqué, and gave it a kind of tatty and unattractive glamour.

With this idea of Margate in my mind, I laughed when I read a year or two later that T.S. Eliot spent a month there in 1922, taking a cure for an attack of

'nerves'. The Margate I knew was likely to give you 'nerves', not cure them, but Eliot's was a different Margate, or rather it was Cliftonville, Margate's then genteel neighbourhood, away from Dreamland (opened in 1920) and the working class hordes. In any case, Eliot was there out of season, in November, and without the foreign students who were to come later, Margate in November 1922 must have been quiet and grey. It appears that the rest did Eliot good, and he was able to work on *The Waste Land,* revising the "Fire Sermon" section and even putting in a few lines about Margate:

> *On Margate sands.*
> *I can connect*
> *Nothing with nothing.*

It could have been worse.

It was nearly thirty years later that I visited Margate again. I left the area for several years, and when I returned it was to live a different and more hectic life of work and family, and Margate, though only about thirty miles away, did not figure in it. In 1997 I went to Margate to record some interviews with Czech Roma asylum seekers. They had appeared in Dover in their scores after a TV programme, aired in the Czech Republic, had depicted the port as a paradise of tolerance and relaxed immigration procedures. And although the immigration authorities turned back ferryloads of asylum seekers, they came again, bringing others with them. And since they had a case for requesting asylum, suffering violence and persecution in the Czech Republic, in the end, several of them were allowed to stay. Margate, just down the road from Dover, took several of the refugees.

By 1997 Margate had collapsed as a seaside holiday resort. Its regular customers preferred to travel to the Mediterranean and further afield. The credit boom brought in by Mrs Thatcher's governments made any fantasy destination possible. Who would choose Margate given that option? And the students of English had also gone somewhere else, if they came at all. The Islamic Republic of Iran preferred to use its money differently, and perhaps it was cheaper to purchase half a dozen English teachers and take them to Riyadh, than to send a crowd of youths to Margate where they would pick up strange ways. So the asylum seekers and refugees were welcome when they turned up, or at least the government money that accompanied them was welcome to the hoteliers and the local council.

This issue drove *The Daily Mail* mad, and it released the vilest xenophobia in

the local press ("This Human Sewage" ran one headline). The press frenzy reminded me of the time I arrived in England, when something similar was happening regarding the arrival of Kenyan Asians. So in 1997 I drove along the Margate promenade past the harbour, and realised that although it had been an age since I was last here, the memory of its old self was still alive. The promenade was almost empty, the PA was silent and the funfair closed down, and even Dreamland was shut after fire damage. The town had turned into an abandoned site: not derelict, but empty, underused, dangerous; an open detention centre and a hostel for displaced people.

They spoke about constant harassment, about violence from local youth, how their children were attacked and how the authorities did nothing to protect them, or moved so slowly that no one was ever arrested and no abuse was averted. One young woman showed me a mouthful of shattered teeth, the result of an assault with a baseball bat. They spoke about revenge attacks that their men undertook, which got them into even further trouble. Having to live like that was hard, but they did not know how they could leave the Czech Republic. Then they saw a TV programme that said Dover was a Roma heaven where families were given housing, children were sent to school, and abusers were put in jail. And so they came.

I think I expected more canniness, more cynicism, more worldliness from them. I don't think there is anything sinful in looking for a better life elsewhere from your place of birth, especially if the life you live is beset with violence and persecution. The Roma asylum seeker was represented as a shifty liar, who was not really persecuted at all and who had come for some easy pickings, as a result of that mischievous TV programme. I think I expected them to be more distraught and angry about their reception. Instead they spoke about the kindness with which they had been treated, about how happy they were to be here, about how good it was to be in a country that was a monarchy (because republics are dictatorships – such ironies!), about how good it felt to be free. I wonder what they are saying now. I should say it was mostly the women who were doing the talking. Some of the men were detained in prison in Chatham and Dover; others had already disappeared into the English undergrowth; those who were there during my conversations sat back watchfully, listening but not saying much. The women talked, describing their anguishes, showing their bruises, while their children clung to them or watched with wide-open eyes. Fighting for their new lives.

The impulse for writing my novel *By the Sea* came in part from this experience. It brought to mind the shabbiness and the meanness that I had witnessed myself on first arrival, the cruelty and hysteria of the press, the weasel words of politicians, and the smug self-pity of the public, or those who put themselves forward as its representative voices. In the last decade or so, Margate has taken in many displaced people, refugees and asylum seekers from Bosnia, Kosovo, the Congo, Belarus, Belfast, as well as some unexpected places: Alexandria (Egypt), Port Elizabeth (South Africa) and Derby (England). Because of the work of several charity and voluntary organisations that advise and help refugees, Margate is not an asylum-seeker gulag. It is far from that, but there is tension. The asylum seekers' lives are tense with insecurity, the organisations that help them are concerned to protect them from misuse, local resentment finds expression somehow, in fights, in vandalism and abuse. And the town looks a wreck, willing to live up to its reputation as a decaying urban centre.

Wendy Ewald is a photographer who works with children. She photographs them and at the same time teaches them how to take pictures for themselves. She records and publishes their life stories. She has done this in many places from Labrador to South Africa and other places in between. She came to work in Margate as part of Artangel's *Exodus* project. Banners of the photographs she took have been hung on the sea wall and on buildings, including Dreamland, some since last year. These photographs generally come in sets of three: a head shot of a child, a back-of-the-head view, and a still life of his or her most valued possessions, installed in various permutations.

The pictures that Wendy Ewald has taken of this diverse group of British and foreign children are tender, moving and beautifully composed. The children's eyes draw you into their stories. In some way they tell the story of the ugliness of our world, and in other smaller ways they show that it is the desire for human fulfilment that prevents dignity from being extinguished. For although the stories they tell are sometimes tragic, the relief they speak of in their reprieve is humble and grateful, altogether convincingly human in its understated yearning. This is as true of the children who travelled thousands of miles to the sanctuary of Margate, as it is for the British children, who have also experienced displacement and uprooting, but have found some solace in this town.

Zaakiyah's photographs were firebombed after the July bombings in London and have since been replaced. The same images have been firebombed again since. The arrangement of her most valued possessions includes a book *Principles of Islam*. The images of Rabbie, an African girl from Congo, were chalkbombed and have since been restored. They have been chalkbombed again. The images of Gemma, a smiling British girl from London, plump with glasses, were paintbombed (red) recently. She was adamant that they be replaced. Since then they have been paintbombed again. What does it mean that all the images attacked were of girls? And what metaphors are contained in the form the vandalism took? It could have been worse.

Some of the stories are too tragic for words, children orphaned and then abandoned by relatives who themselves fear the unnamed retribution that had orphaned the child in the first place. Reza from Afghanistan is such a one. His father was killed for some reason he is not clear about. His uncle sent him to Iran to live with people he did not know, then he travelled across half the world, menaced by men and machines, with a resourcefulness that is staggering. Reza was living with a foster family in Kent. He has now been given his own apartment and is going to school for over a year. Other stories are not so optimistic. Uryi from Belarus, whose life seemed to be full of promise in the U.K., has disappeared with his mother, probably deported; Rabbie and Celeste from Congo have also disappeared with their mother. And so on. But for now, the testimonies of all these stubborn young lives have found fitting expression in the banners that Wendy Ewald has made and raised in Margate.

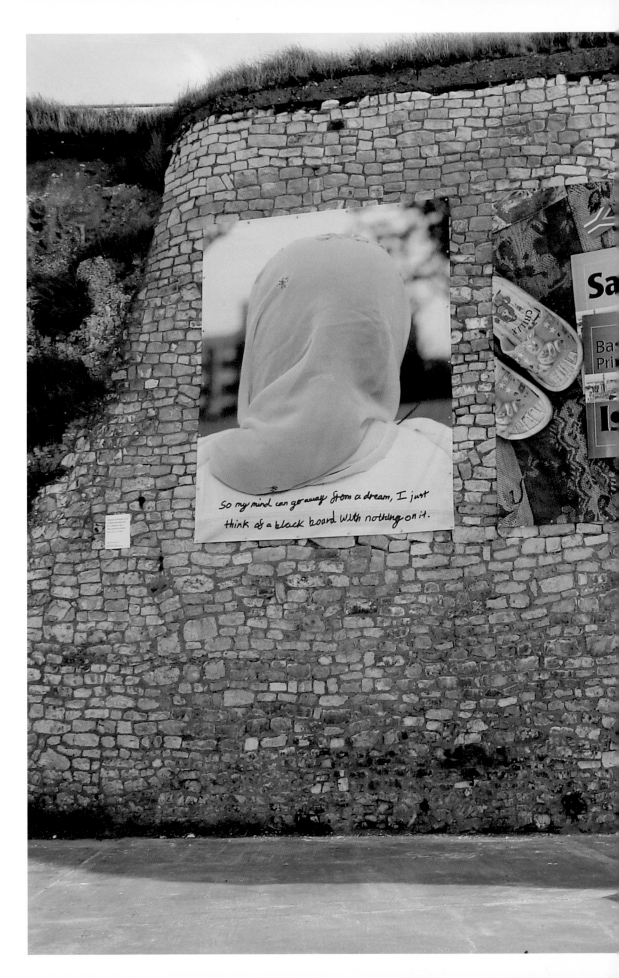

So my mind can go away from a dream, I just think of a black board with nothing on it.

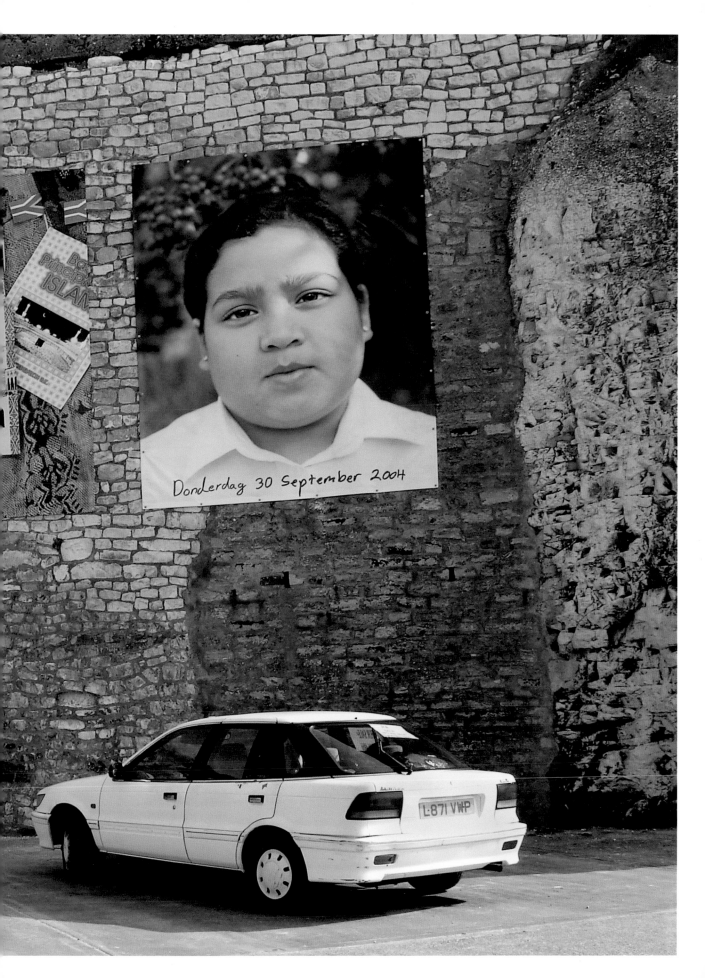

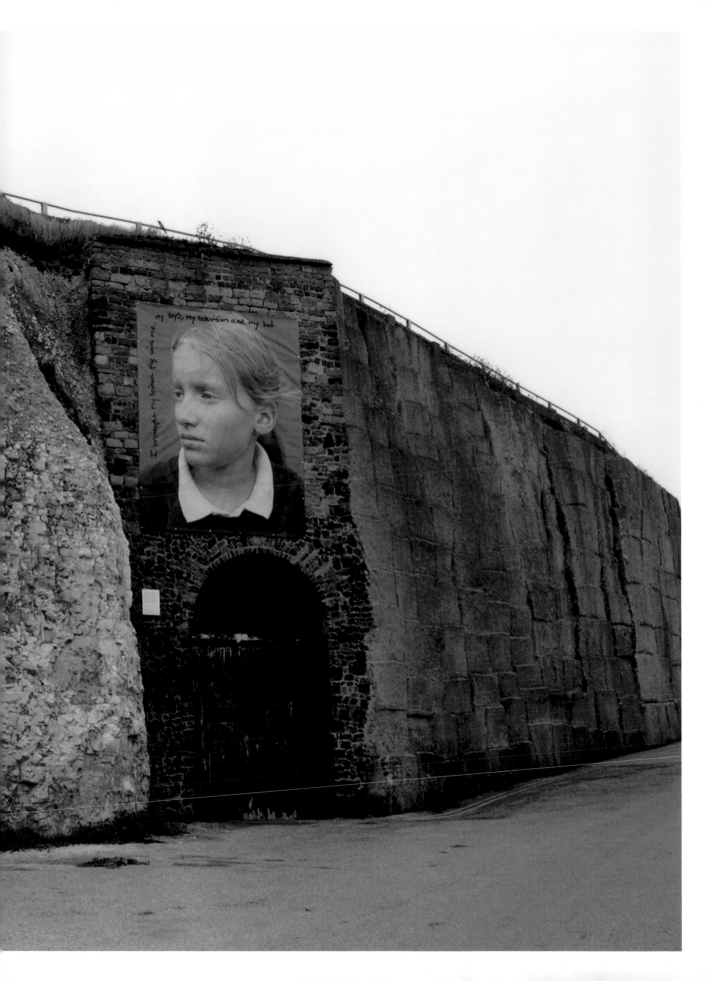

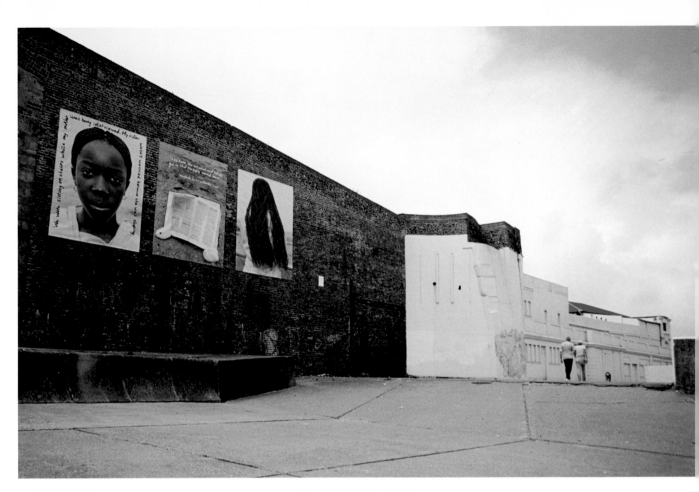
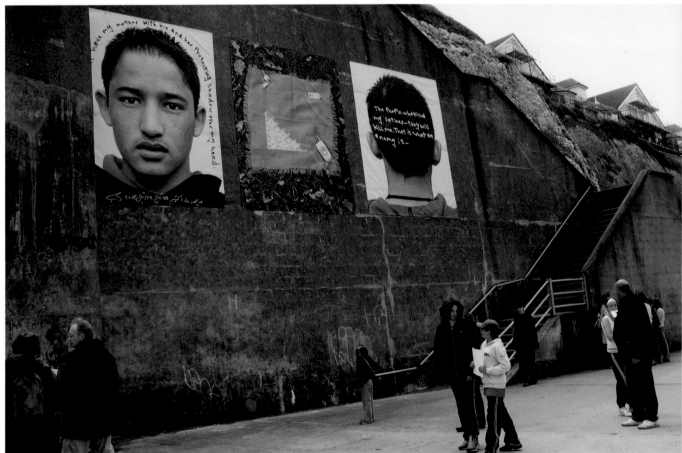

CASH BINGO

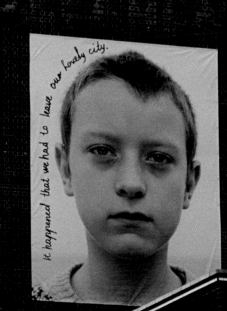

It happened that we had to leave our lovely city.

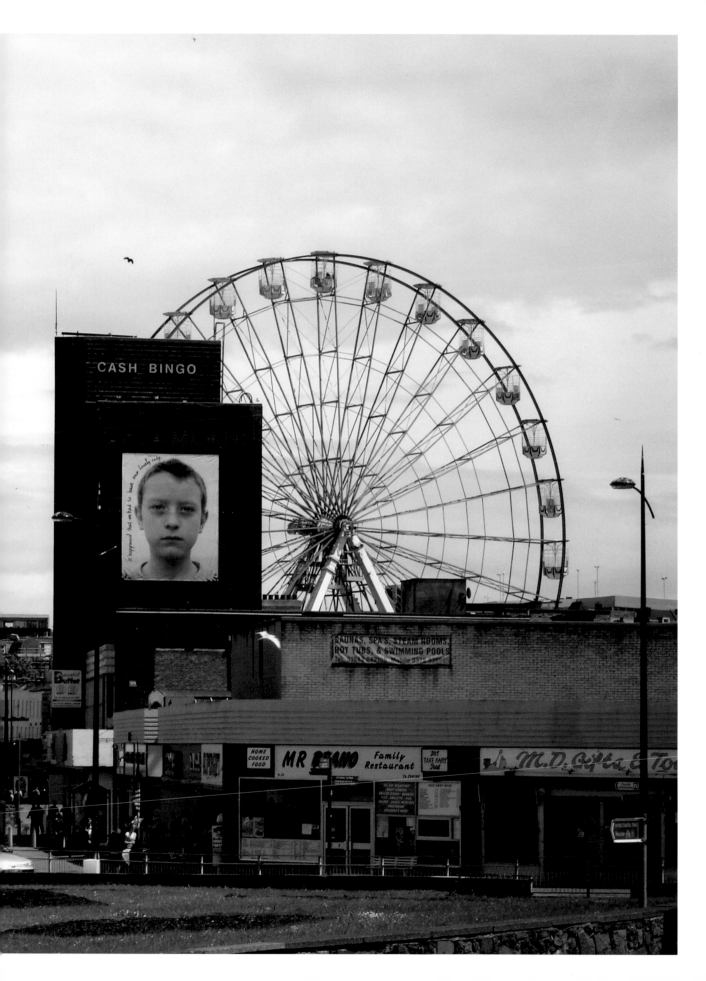

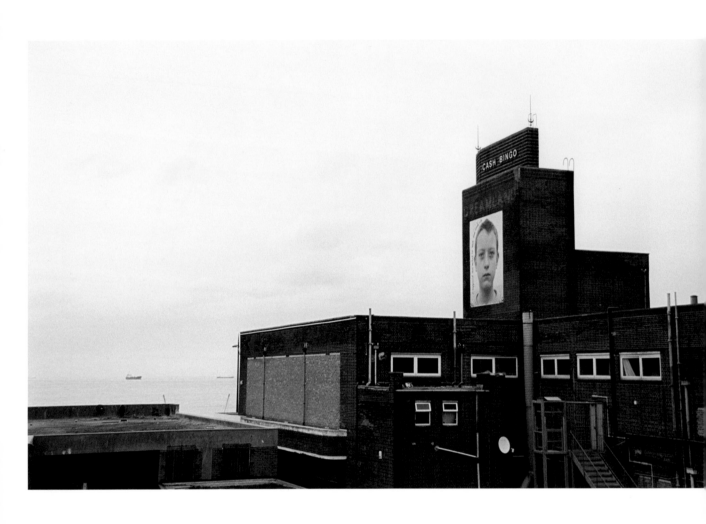

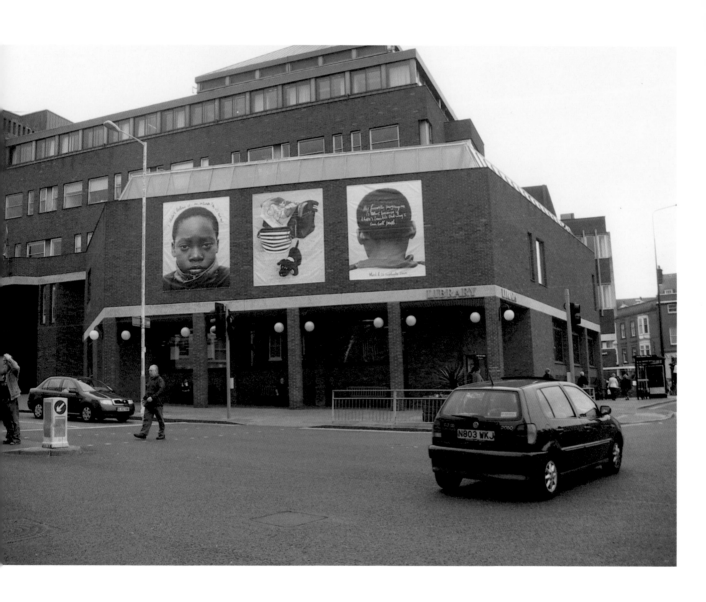

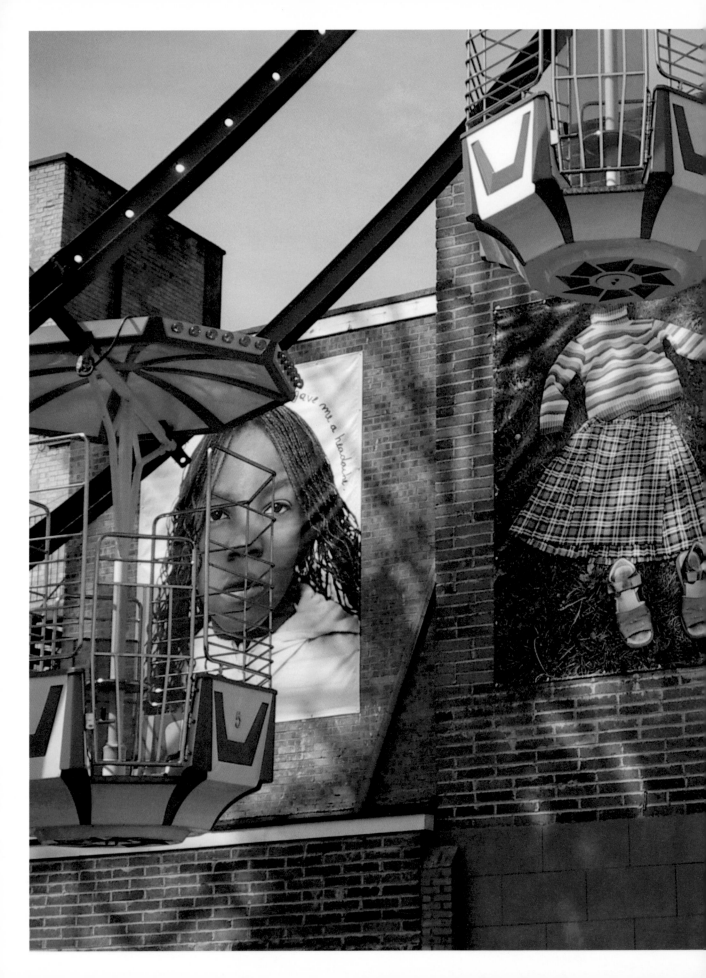

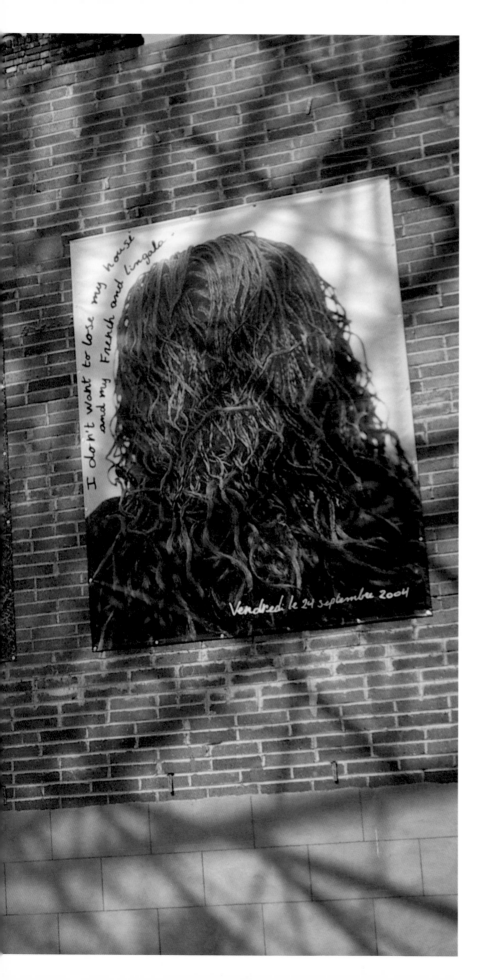

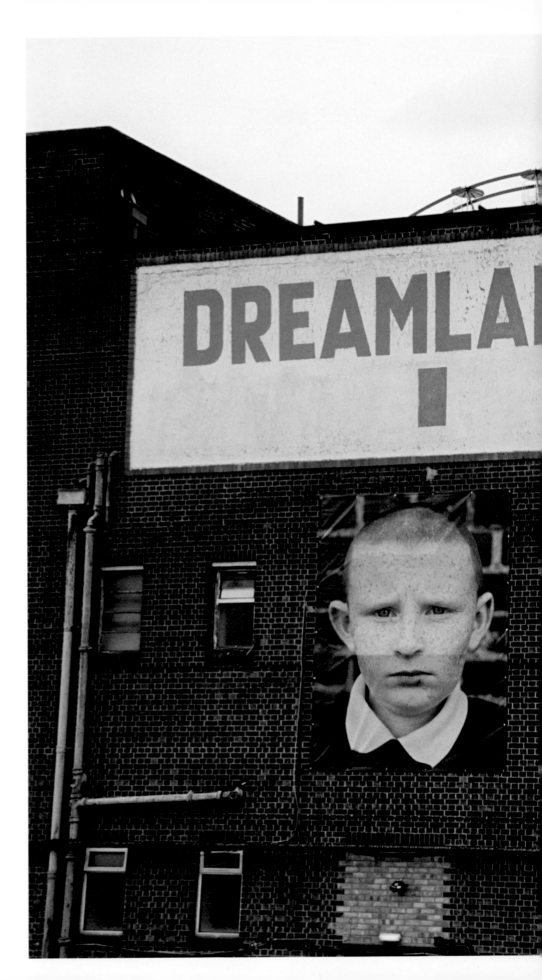

D WELCOMES

SLOW
CHILDREN
CROSSING

My dad said that he was
wanting to leave because it
was trouble over there.
Fighting, windy bricking
all sorts.

09/27/04

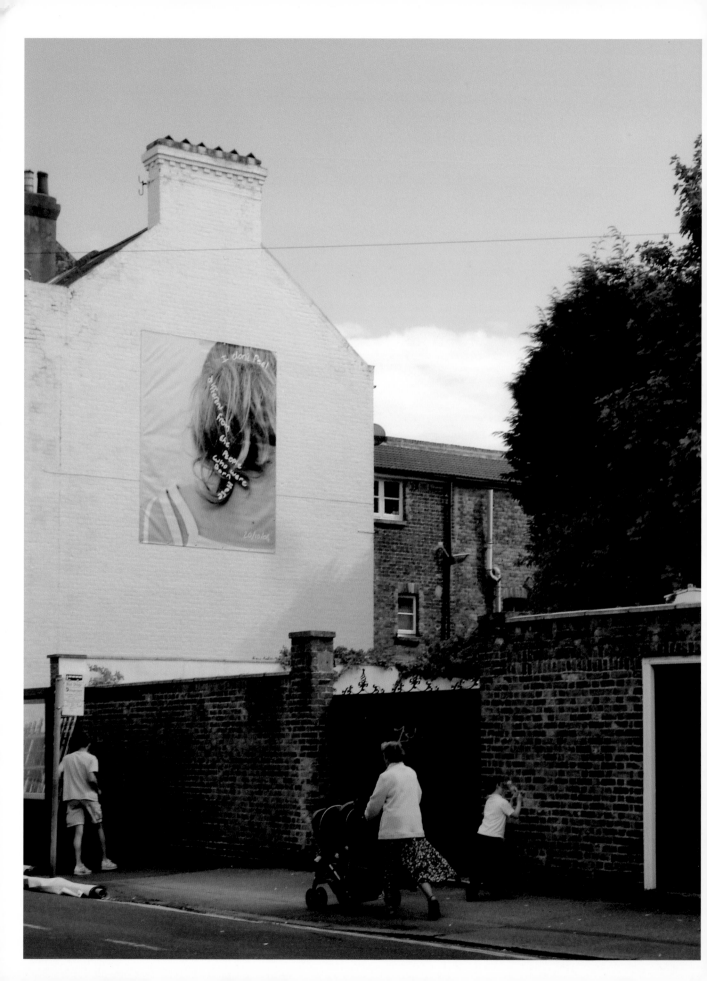

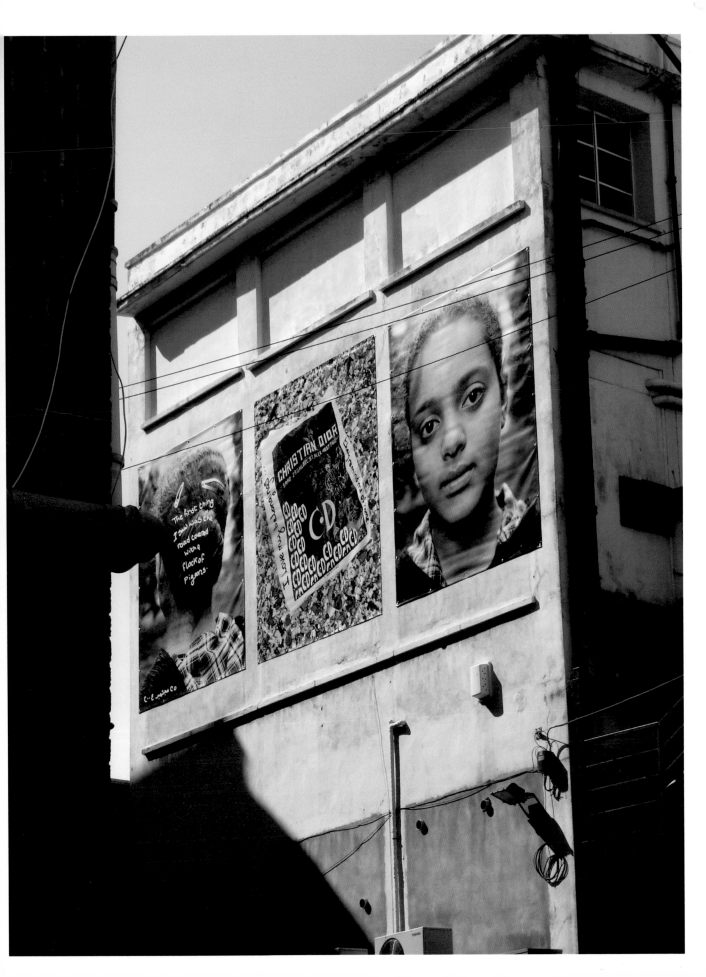

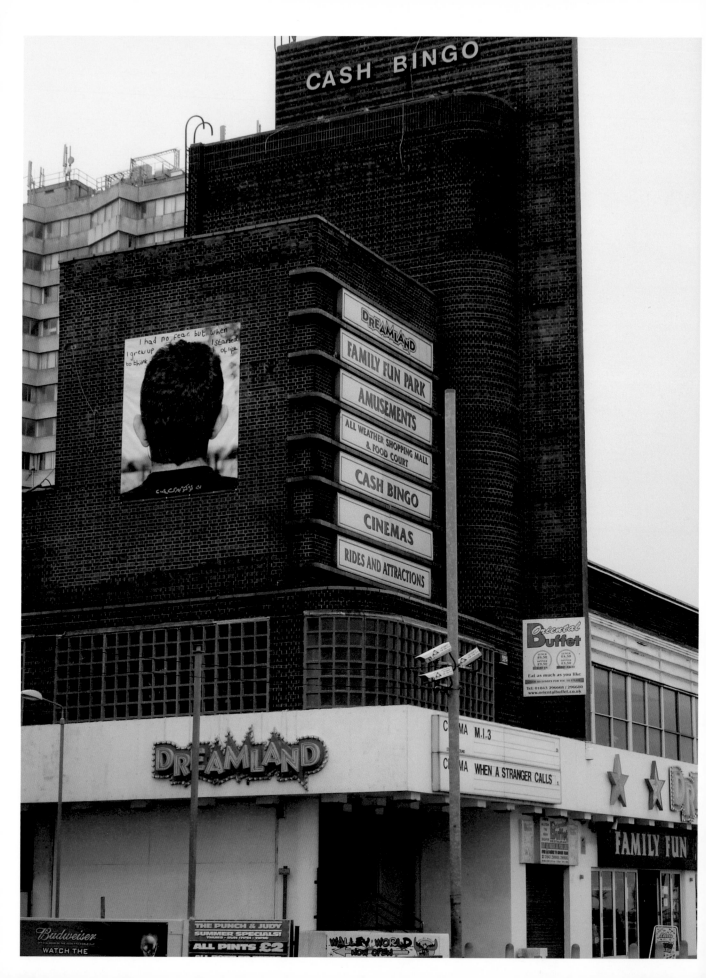

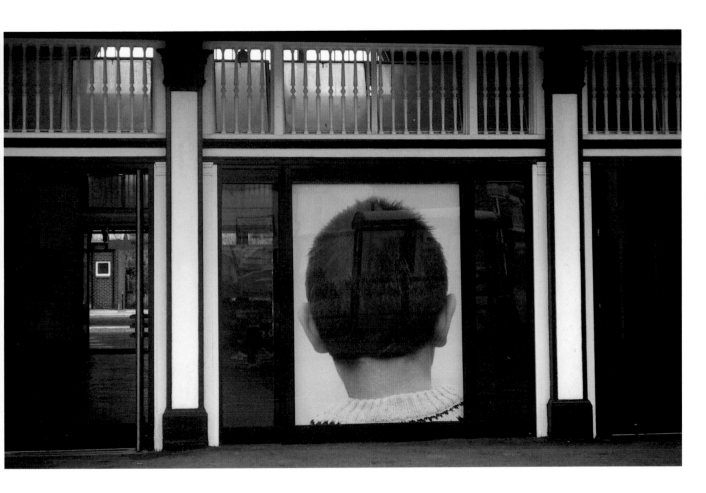

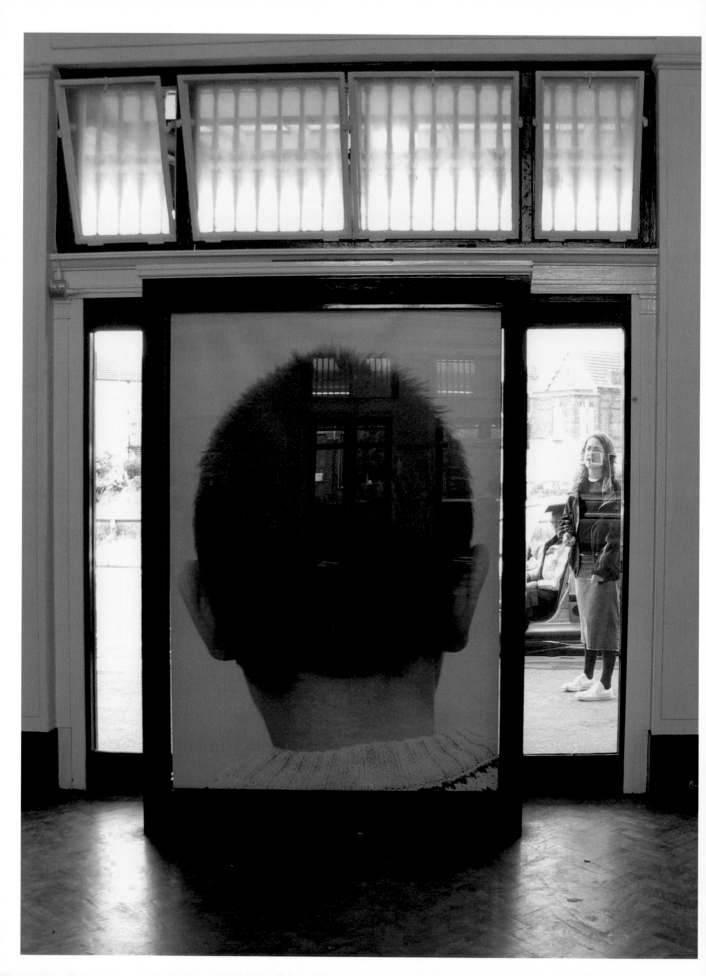

Wendy Ewald
has collaborated for more than thirty years with communities all over the world in pictures and words. She has conducted workshops with children, families, women and teachers in Canada, Colombia, Holland, India, Italy, Morocco, Saudi Arabia, South Africa and the United States. She has been the recipient of prestigious research fellowships, including a Fulbright Scholarship (1982), a MacArthur Fellowship (1992) and a Senior Fellowship at the Vera List Center for Art and Politics at the New School for Social Research (2000–2003).

In addition to her innovative workshops, Ewald has taught and lectured extensively in tertiary colleges and art institutions across the world. Her work has been exhibited in museums and galleries including the Whitney Museum of American Art, Fotomuseum Winterthur, the Addison Gallery of American Art, Mass., the Nederlands Foto Institut and the Corcoran Gallery of American Art in Washington.

Currently, Ewald is artist-in-residence at the John Hope Franklin Center, and Senior Research Associate at the Center for Documentary Studies at Duke University, NC. *Secret Games,* a retrospective survey of her work was published in 2000. *To a Promised Land* is her tenth book.

Abdulrazak Gurnah
was born in 1948 in Zanzibar and teaches in at the University of Kent. He is the author of six novels, which include *Paradise, Admiring Silence* and *By the Sea. Paradise* was short-listed for both the Booker and the Whitbread Prizes, and was published by Bloomsbury in a new edition in November 2004.

His new novel, *Desertion,* was published by Bloomsbury in May 2005.

Jeremy Millar
is an artist, writer and curator based in Whitstable, Kent. In 1994 he curated his first exhibition, "The Institute of Cultural Anxiety," at the ICA London. Since then, Millar has continued to curate exhibitions around the world, including Media_City Seoul, Korea (2000) and the Brighton Photo Biennial (2003), of which he was the inaugural director. He writes regularly on art and culture. In 2005 he co-edited a book on place with Tacita Dean, for Thames and Hudson's series "Art Works." His most recent project is a film and exhibition based upon Marcel Duchamp's 1913 visit to a coastal town in Kent (near where Millar lives) in which he speculates on the effect that the visit had upon the artist's developing ideas for *The Large Glass.*

Michael Morris
has been Co-Director of Artangel, with James Lingwood, since 1991 and Artangel Media set up in 2000. Since that time, Artangel has pioneered new ways of collaborating with artists and engaging audiences in an ambitious series of new commissions for particular places in London and beyond. Major new works have been produced by artists including Gregor Schneider, Jeremy Deller, Rachel Whiteread, Kutlug Ataman, Francis Alys, Janet Cardiff, Penny Woolcock, Steve McQueen, Atom Egoyan and Douglas Gordon amongst many others.

Morris also directs Cultural Industry Ltd, a UK-based international production company with particular ongoing commitments to Robert Lepage, Pina Bausch and the theatrical hybrid *Shockheaded Peter.*

Louise Neri
is an editor, curator and writer working in the visual and performing arts. From 1990–2000 she was an editor of international journal *Parkett,* collaborating with artists and writers on articles, features and editioned artworks. At the same time, she developed and published innovative artists' monographs such as *Looking Up: Rachel Whiteread's Water Tower* and *Silence Please! Stories after the works of Juan Munoz,* as well as curating several large-scale international biennial exhibitions. In 2003–4 she developed and directed experimental programming at the Theater am Turm/Bockenheimer Depot in Frankfurt, conceiving a multi-disciplinary program of dance, performance, music, radio, film and discussion, which included projects initiated and produced by TAT with local and international artists working with the diverse communities of Frankfurt.

Currently Neri is working with Gagosian Gallery in New York on programming and publishing.

Towards a Promised Land
was commissioned and produced by Artangel, and funded by the Small Voice Foundation with the support of Creative Partnerships, Kent.

Artangel
is supported by Arts Council England, London; The Company of Angels and the Calouste Gulbenkian Foundation.

Wendy Ewald's *Towards a Promised Land*
is an Artangel Interaction project. Artangel Interaction projects are led by artists working with participants who are often marginalised or overlooked by mainstream culture.

Small Voice Foundation
is a charity founded by Sean French and Nicci Gerrard to donate money to one-off projects.

Artangel

James Lingwood / Michael Morris — Co Directors
Cressida Hubbard — Administrative Director

Sian Emmison — Finance & Publications Administrator
Janette Scott — Head of Press and Publicity
Cathy Haynes — Head of Interaction
Maitreyi Maheshwari — Interaction Associate
Melanie Smith — Head of Production

Elisa Birtwhistle — Administrative Assistant
Tom Dingle — Production Assistant
Sarah Davies — Administrative / Interaction Assistant
Bethany Pappalardo — Development Assistant

Artangel has pioneered new ways of collaborating with artists and engaging audiences in an ambitious series of new commissions since the early 1990s. By producing exceptional new work in challenging contexts, Artangel has been at the forefront of cultural debate, both in the UK and abroad; www.artangel.org.uk

Creative Partnerships Kent

Anna Cutler — Director
Fiona Kingsman — Project Manager

Creative Partnerships is a programme managed by Arts Council England, the national development agency for the arts in England. It gives young people in thirty-six disadvantaged areas across England the opportunity to develop their creativity and their ambition by building partnerships between schools and creative organisations, businesses and individuals. Creative Partnerships aims to demonstrate the pivotal role creativity and creative people can play in transforming education in every curriculum subject for children of all ages and abilities.

www.creative-partnerships.com

Towards a Promised Land

Fiona Kingsman — Project Manager
Pete Mauney — Assistant to Wendy Ewald
Lucy Pardee — Project Researcher and Interviewer
Andrew Palmer — Film Documentation
Oli Cohen — Sound Recordist
Alex Glynn — Sound Recordist
Margaret Dewys — Sound Editor and Designer
Maria Bota — Sound Coordinator

Banner installation:
Hayden Suter — Head Installer
Marc Craig, Russell Keen, Lucian Quatermass,
Alan Robertson, Gallvic Walker, Kyle Holden and Paul Suter

Outfitters Gallery & Margate Library Exhibitions:
Roy Smith — Head Artist
Claire Smith — Artist at Margate Library
Ben Kidger — Manager, Outfitters Gallery
Heather Hilton — District Manager, Thanet Libraries
Sarah Hannaford — Customer Services Manager, Thanet Libraries

Special thanks to
the staff at Margate Library and the guides at the exhibition.

We especially thank
all of the children who have collaborated on this project: Ashlea, Christian, Elisio, Gareth, Gemma, Glenn, Lanny,
Long, Max, Celeste, Mariam, Naomi, Omar, Rabbie, Reece, Reza, Shakeeb, Tarnya, Uryi, Zaakiyah and Zughdie and
those who wish to remain anonymous

We are very grateful to
Ali, Arpad, Chantelle, Fatima, Ivan, Rosie and Zakariyah, who read for the audio recordings, and Emma, Hannah,
Kathryn, Paris, Louis and Yasmin who helped with the library exhibition.

Artangel also thanks
Julie Wilson and Danielle Skinner at Hartsdown Technology College; Kent County Council Asylum Unit;
Migrant Helpline; The Nayland Rock Hotel; Linda Pickles, Justine Hopkins and Linda Davidson at Northdown
Primary School; everyone at The Orchard Centre; Brian White at Thanet District Council; and Waterbridge
Properties Ltd. We also give sincere thanks for their help and support to Luciane Adamy, Hazel Addley,
Rebekah Altman, Catherine Botibol, Neville Borck, Charles Bourner, Doug Brown, Ceri Buckmaster, Huong Chu,
Jeremy Cole, Edgar Costa, Peter Curtis, Richard Elkan, Mahmoud El-Kastawy, Sheikh Ewas, Sandy Ezekiel,
Dr Rebwar Fatah, Roger & Suzy Gale, George Georgiou, Jorge Goia, Basharmal Golchin, Dr Vadim Golubev,
Frank Horvat, Mike Humber, Shakeeb Ismail, Fahim Khan, Kousay Kheder, Barry Landeman, Julie Larner,
Roger Latchford, Gerry Lidgett, Kevin Lodge, Adriana Marques, Joe McCarthy, Makabi Ndofula, Trang Nguyen,
Falah Phaily, Jean Reynolds, Jon Sandford, Rebecca Smith, Frank Thorley and staff, Rene Tolno,
Mick & Shirley Tomlinson, Catarina Venancio, Will Whelan, Kathryn Woodham, Hashim Younosi
and Seyar Zalmai.

The stories in *Towards a Promised Land*
reflect universal experiences and our desire to create a better life for ourselves and our families.

First and foremost,
I would like to thank the children and their families for sharing these stories of moving and starting life over. I'm especially awed by the clarity and courage of Zaakiyah, Gemma and their families.

I am deeply grateful for the sensitivity and dedication of the team
that worked with me on site for this ambitious project. Cathy Haynes, Maitreyi Maheswari, Pete Mauney and Lucy Pardee were committed at every step to helping me and the kids carry out our ideas. Lucy's interviews provided an essential part of our relationship with the kids and their families. Fiona Kingsman kept contact with the kids and their families, as well as working brilliantly with her team of installers, especially Hayden Suter. Michael Morris's curatorial presence was an inspiration and a constant sounding board.

It has been a pleasure to work with Louise Neri
on this book. Our conversations expanded my understanding of the project. Louise's editorial concept for the book gave the project the context it deserves. Thanks to Laurent Benner for his insight and patience and for giving the book its meaningful and dynamic form.

Thanks to the writers
who contributed their thoughts and observations to the book.

Thanks to Gerhard Steidl and his production team
for bringing the book to life in print.

Wendy Ewald

Captions

8–9 Margate, aerial view

Captions for Wendy Ewald: Portrait of a Praxis

29 New Brunswick, Canada,1972; Houston, Texas, 1989
30 Vichya, India,1989; Asilah, Morocco, 1995
31 Durham,North Carolina,1994
32 Ráquira, Colombia, 1982; Kentucky, 1975
33 Soweto, South Africa, 1992; Orange Farm, South Africa, 1992
34 Margate,U.K. 2005

NB. Children's photographs are captioned only where specific title was provided by child

Ashlea: Margate (58)
Elisio: My ad for a new kind of clock (68); The best player in the world (69);
 A farewell to great friends (70)
Gemma: Baby Tia, what is she doing? (81); My dogs (82)
Glenn: My dad's vehicles (85); My favorite vehicle – Pong (85)
Long: A person is punished for murder (91); My father working (93);
 I'm going to school (93); The time when me and my father were together (93)
Mariam: I love you my sisters (96); I love this view [photograph by Mariam's sister], (96);
 I don't like it when the sea is cold (97); I don't want to brush my teeth (97)
Max: Family forces (100); Was he real? (100)
Rabbie: My arrival at the Nayland Rock (107); My family that I love (109);
 The Nayland Rock Hotel (109)
Reece: My sister the alien (113); Zombified (113)
Reza: The pen says, "I'm the King of the world. Whoever is the penholder will be given
 power by me..." (119); "In this short world of two days, why do you walk so proudly?
 Even if you become Suleiman, in the end you will still belong to the ants." (119)
Shakeeb: The dry wood provides a good scene in this place (122); He cannot move (123)
Taryna: The view from my brother's window (126); The Isle of Man, an imaginary map (127);
 Zombie (128)
Uryi: My mum (130)

Photo Credits & Copyrights

Wendy Ewald: all photographs unless otherwise specified
Pete Mauney: Back cover image and images on page 33, 141, 142 and 143
Simon Moores (www.thanetlife.com): page 8–9
Jeremy Millar: page 23–28
Fred Baldwin: page 29
Julie Stovall: page 32
Rick Bell: page 33
Thierry Bal: page 152, 162–3, 164–5, 168
Artangel Trust: page 169, 170–1

First printed September 2006

Editorial concept: Louise Neri and Wendy Ewald
Editing: Louise Neri
Graphic Design: Laurent Benner (Reala) & Lea Pfister
Proofreading: Maria Bota
Production and printing: Steidl

Steidl
Düstere Str. 4 / D–37073 Göttingen
Phone +49 551-49 60 60 / Fax +49 551-49 60 649
E-mail: mail@steidl.de
www.steidlville.com / www.steidl.de

ISBN 3-86521-287-5
ISBN 13: 978-3-86521-287-0
Printed in Germany